POSTERS FOR CHANGE

Tear, Paste, Protest:
50 Removable Posters

PRINCETON ARCHITECTURAL PRESS · NEW YORK

CULTIVATE
RESILIENCE

Natalie Good, *Cultivate Resilience*, 2017, vintage wood type and cuts.

Contents

Justin Kemerling, *Dissent Is Patriotic*, 2017, digital. First used as a shirt design by the American Civil Liberties Union (ACLU).

Preface

Have a voice. Use it.

When the world goes crazy, as it sometimes does and seems to have recently, we, collectively, need to remember that our voices do matter and need to be heard. Here at Princeton Architectural Press, we realize that this is a moment to use our expertise to have a voice and to invite others to join us in expressing their views. We know books, we know design, and, after much discussion, decided we could use these skills to let our voices, and those of our readers, be heard on a global scale, on issues like immigration, health care, civil and gender rights, and the environment, issues that touch each of us every day. These crises have no boundaries, but neither do books. We created a call for entries and sent it out.

First, we asked our colleagues, friends, and everyone we knew to submit posters. The deadline was tight, only four weeks, but we still received eight hundred poster designs, from about three hundred contributors, representing thirty-six countries. The issues we face are global indeed and clearly on many people's minds. The fifty posters in this book represent the best of the submissions, and a representative sample of the entries we received, in terms of country of origin, area of concern, and graphic style.

Finally, we selected four small nonprofits to receive the royalties from the book sales. These include:

→ **The Advocates for Human Rights,** which works to implement international and local human rights standards, promote civil society and reinforce the rule of law.
→ **Border Angels,** a nonprofit, humanitarian group that organizes search and rescue campaigns of missing persons in areas of the desert between the US and Mexican border.
→ **The Sylvia Rivera Law Project,** which works to ensure that all people are able to choose their own gender identity and expression without persecution.
→ **Honor the Earth,** which creates awareness and support for Native environmental issues and develops financial and political resources for the survival of sustainable Native communities.

Posters in this collection were selected for a variety of reasons. We looked for a mix of media from artists who are geographically and culturally diverse. Both digital and hand-drawn examples were chosen in different styles, some refined, even elegant, others crude, formal, playful, or mock-authoritarian. Above all, we wanted to see graphic design at its best: bold, informative, emotive, impactful, and memorable, qualities we think every poster in this collection has, and then some.

In the end, we want people to have posters that are well printed on sturdy paper and easily detachable to clearly communicate the pressing need to be heard in these trying times, loudly, legitimately, and with style.

Jennifer Lippert, Editorial Director
Hudson, New York
August 2017

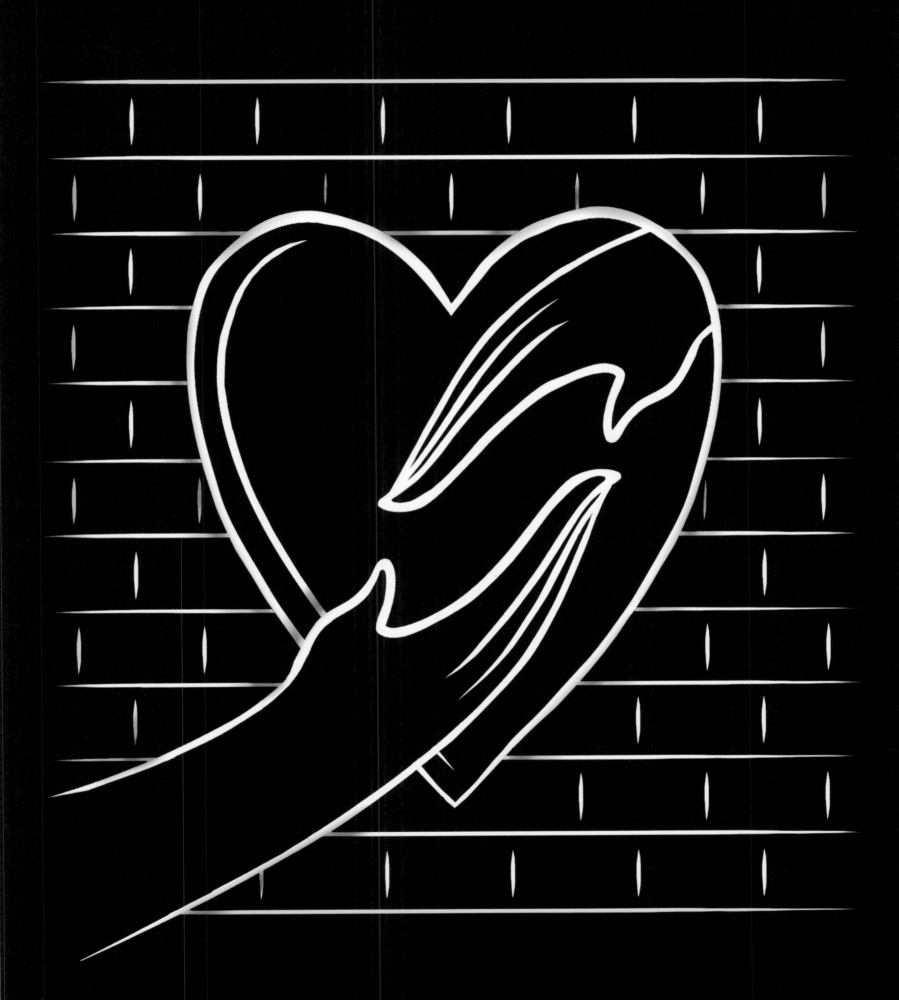

Andrea Arroyo

← **OUR HEARTS WILL BREAK
A THOUSAND WALLS**
Ink and digital
(First appeared in the publications the *Journal
of the Print World*, *Resist!*, *El Diario La Prensa*,
and in the exhibition space Unnatural Election)

Andrea Arroyo
New York, NY, USA

Andrea Arroyo is an artist working in painting,
illustration, public art, and site-specific instal-
lation. Her work is exhibited internationally,
and her honors received include New York
Foundation for the Arts Fellowships, Global
Citizen Award Artist, 21 Leaders for the 21st
Century, Outstanding Woman of New York,
Northern Manhattan Arts Alliance Award,
Puffin Foundation Award, and Lower Manhattan
Cultural Council Award. Her artwork has been
published extensively including on the cover
of the *New Yorker* and the *New York Times*,
and has been the subject of over two hundred
features in the international media.

andreaarroyo.com

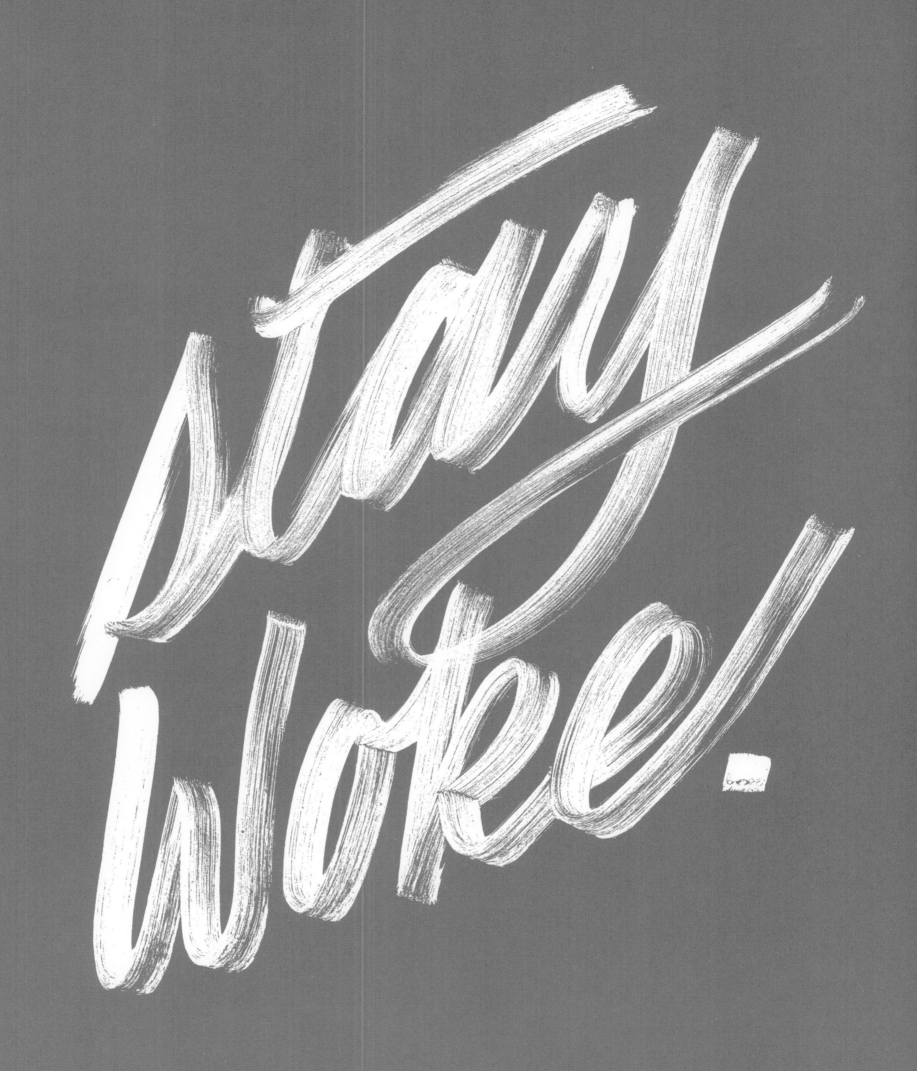

 STAY WOKE
Screen print

Spencer Bagert
Baton Rouge, LA, USA

This poster was originally included in the
Hello Poster Show, a Seattle-based pop-up
fundraising exhibition featuring silkscreened
posters created by designers and artists
from around the world.

Spencer Bagert is a graphic designer, lettering
artist, and graduate of Louisiana State University.
Lettering and sign painting from the early
twentieth century inspire him.

spencerventure.com

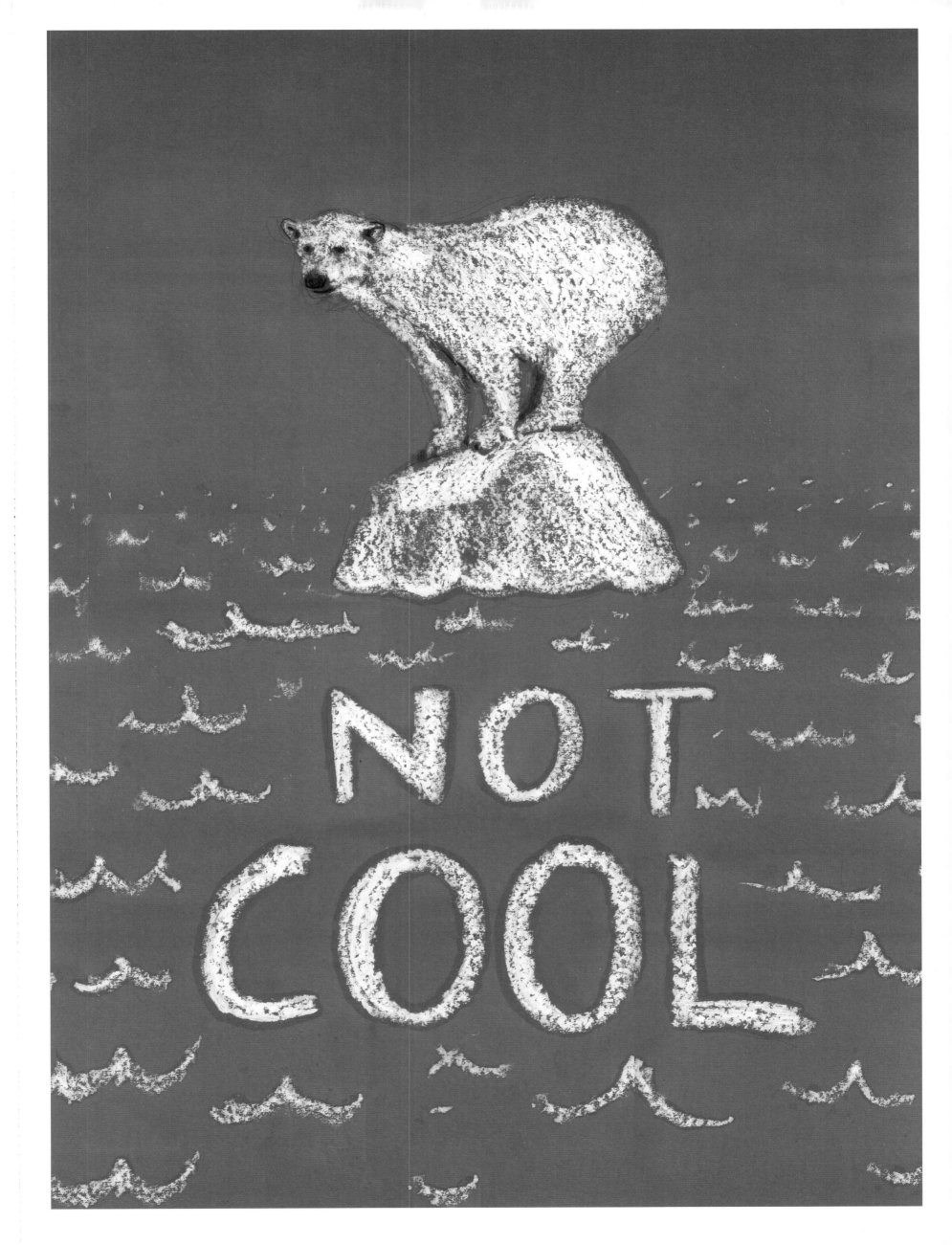

← **NOT COOL**
Oil pastel and charcoal on blue poster board
(Originally created for a climate change march)

Daniel Baxter
Red Hook, NY, USA

Daniel Baxter is an award-winning illustrator
with over twenty-five years of experience. His goal
is to create clever and witty solutions for each
project he works on. He provides creative content
for magazines, newspapers, children's books,
and websites. Clients include the *New York Times*,
Random House, the *Wall Street Journal*, *Time*
magazine, Chronicle Books, and Microsoft.

danielbaxter.com

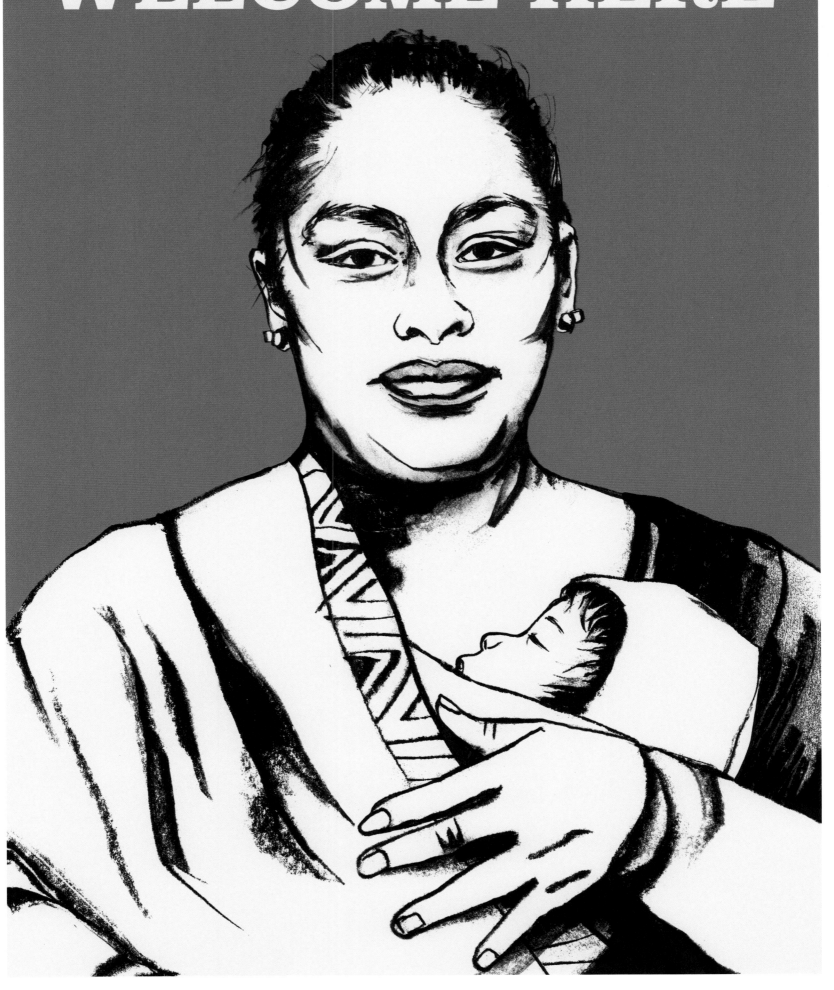

← **IMMIGRANTS ARE WELCOME HERE**
Digitally altered pencil drawing

Micah Bazant
Berkeley, CA, USA

Micah Bazant is a trans visual artist who works
with social justice movements to make change
look irresistible. They create art inspired by
struggles to decolonize from white supremacy,
patriarchy, ableism, and the gender binary.

micahbazant.com

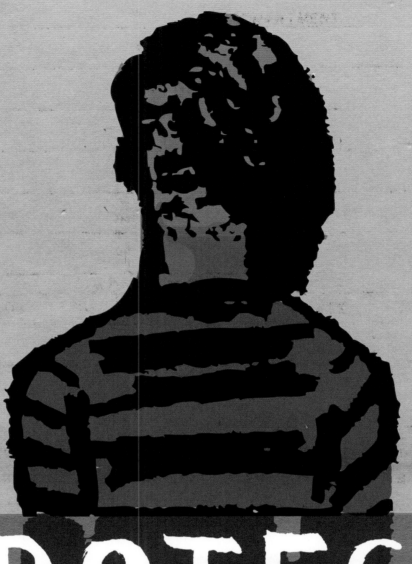

PROTECT
TRANS
youth

← PROTECT TRANS YOUTH
Digitally altered ink on paper, watercolor,
and scanned paper

Lauren Simkin Berke
Brooklyn, NY, USA

The image in this poster was one of Lauren Simkin
Berke's favorite unused rough sketches from
when they were working on the cover illustration
for the book *Rethinking Normal* by Katie Rain Hill.
The text was added to create a simple meme for
use on social media.

Lauren Simkin Berke creates illustrations that
are both figurative and narrative, intended
to evoke the experiential memory of the reader.
They work for clients such as the *New York Times*,
the *Boston Globe*, Simon & Schuster, and Rémy
Martin, and they self-publish art books and zines
under the name Captain Sears Press.

simkinberke.com

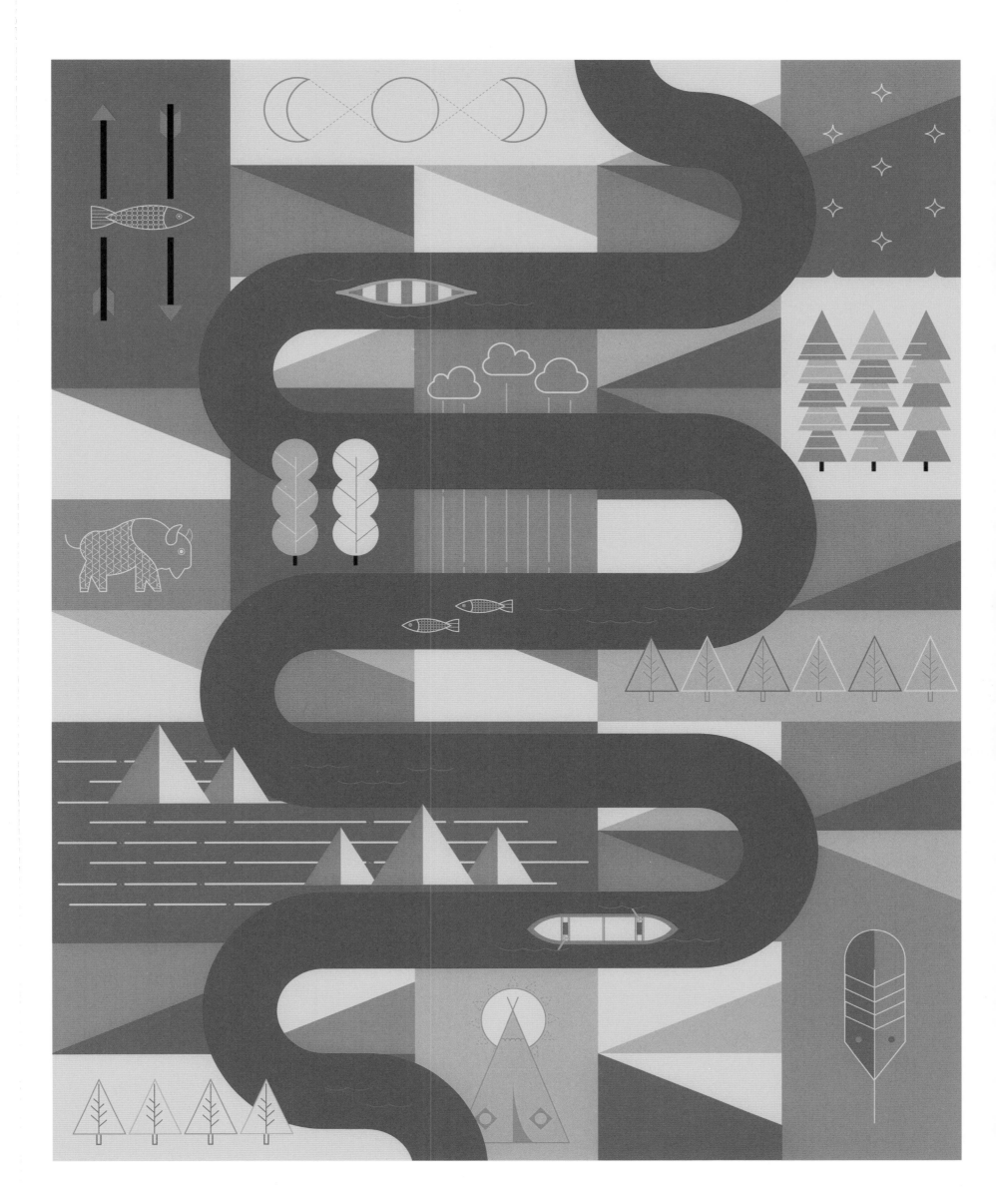

← THE JOURNEY
Digital

Adam Chang
Seattle, WA, USA

Adam Chang is a freelance art director and designer. When he's not stuck in front of the computer, he likes to take photographs, travel, and eat fruit snacks.

sametomorrow.com

HOW·CAN
WE·MOVE
FORWARD
WHEN·EVERY
THING·IS
BACKWARD

← **HOW CAN WE MOVE FORWARD WHEN
EVERYTHING IS BACKWARD**
Digitally altered flat brush and India ink

Spencer Charles
Brooklyn, NY, USA

As a left-handed person, Spencer Charles
has found it useful to practice mirror writing.
Originally the whole poster was written this
way, but the top half was later digitally adjusted
to read normally. He has struggled a great deal
with practicing calligraphy, but he has found
that approaching the practice from a different
angle has allowed him to understand it in a more
complete way. He thinks a similar lesson could
be applied to the current political climate.

Spencer Charles is a graphic designer specializing
in letter design. With his wife, Kelly Thorn, he runs
a small studio in the Pencil Factory, a building
shared by independent designers. He and Kelly
met when they worked together at Louise Fili Ltd.

charlesandthorn.com

"The nation that destroys its soil, *destroys itself.*"

FRANKLIN DELANO ROOSEVELT

← **RICH AMERICAN SOIL**
Digital composite of dirt and ink

Justin Childress
Dallas, TX, USA

Fundamental questions of citizenship can be
tied back to two ideas: blood and soil. For this
poster design Justin Childress uses the concept
of "rich soil" to make a statement about the
diverse collection of backgrounds that built
(and continue to build) the United States.
The unique flourishing of the United States is
intimately tied to its history of immigration.

Justin Childress is a designer and Creative
Director at Switch, a friendly branding and inter-
active studio, and a lecturing faculty member for
Southern Methodist University's Master of Arts in
Design and Innovation graduate program.

justinchildress.co

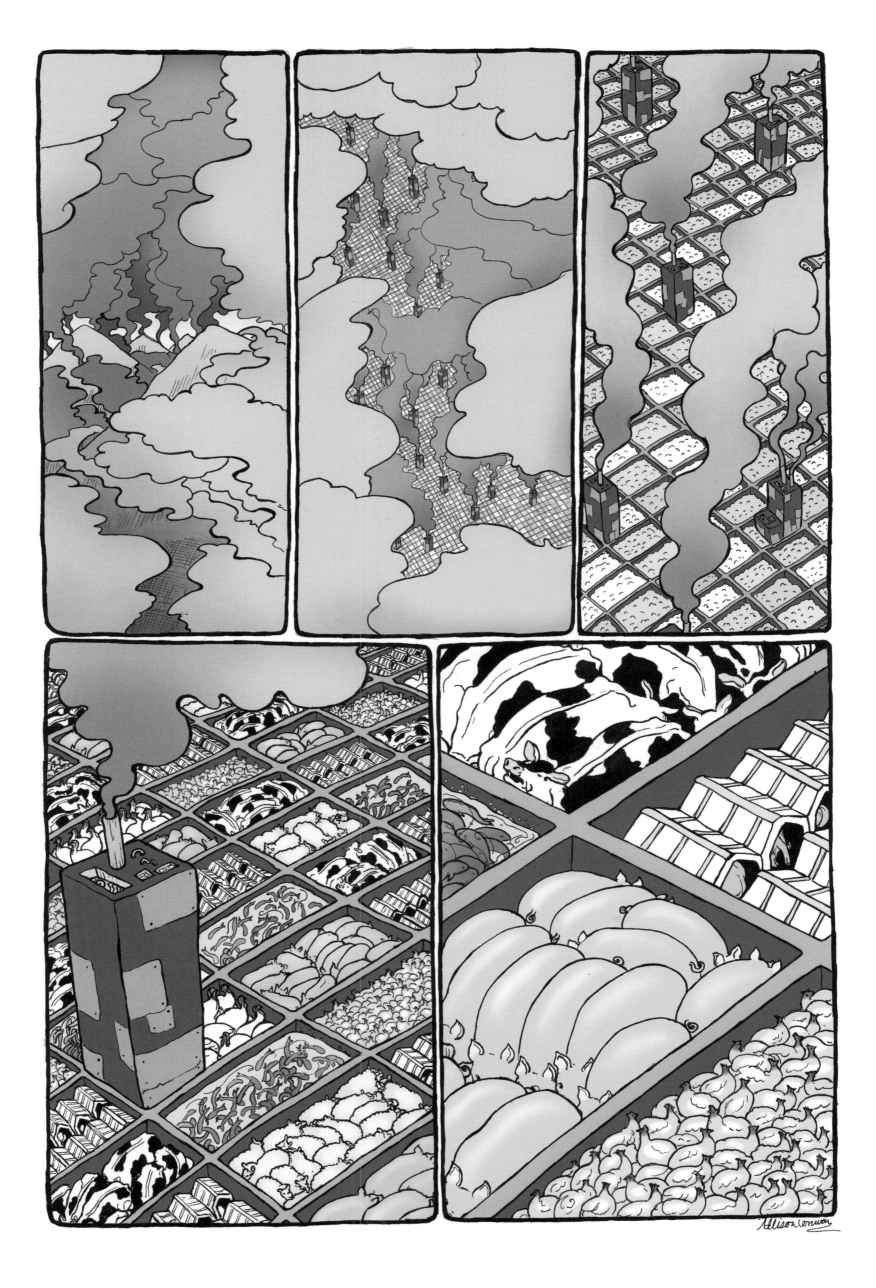

← **AMERICAN LANDSCAPE**
Digitally altered pen drawing
(First published in *Resist!*, a political comics
publication)

Allison Conway

Macedon, NY, USA

Allison Conway is an illustrator based in New York
and a graduate of the Savannah College of Art
and Design. Allison's clients include the *New York
Times*, the *Boston Globe*, *VICE*, and *MERRY JANE*.
Her detailed illustrative style explores the serious
and the fanciful, often combining elements of
both horror and humor to convey her message.

allistrations.com

Logic will get
you from A to B.

Imagination
will take you
everywhere.

—Albert Einstein

← **IMAGINATION**
Digital

Jillian Coorey
Stow, OH, USA

Jillian Coorey is an associate professor in the
School of Visual Communication Design at Kent
State University, where she teaches courses
from foundation to graduate level. Her research
areas include design pedagogy, typography, and
K–12 design education. She has presented
research and exhibited design work at national
and international juried venues.

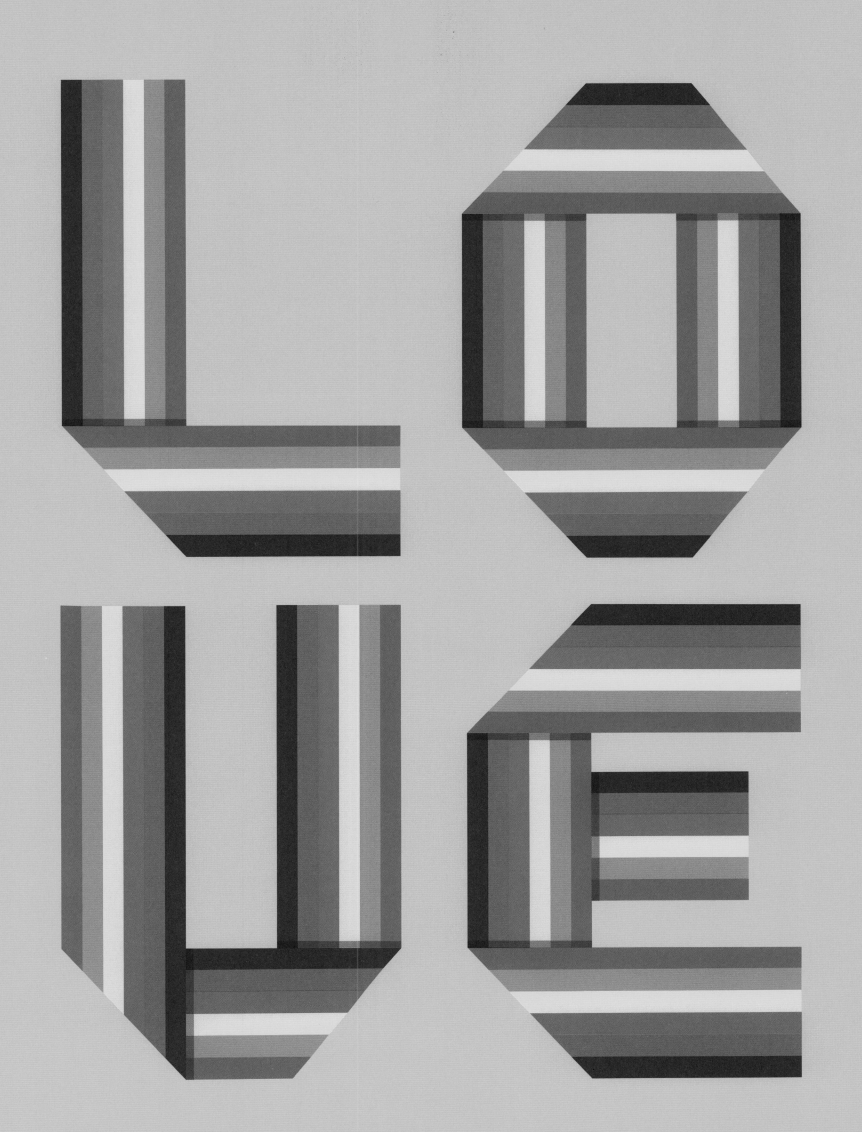

← **LOVE WINS**
Digital

Curtis Dickie
Seattle, WA, USA

Curtis Dickie is a designer and illustrator who
currently works for the ACLU of Washington.

cargocollective.com/curtisjdickie

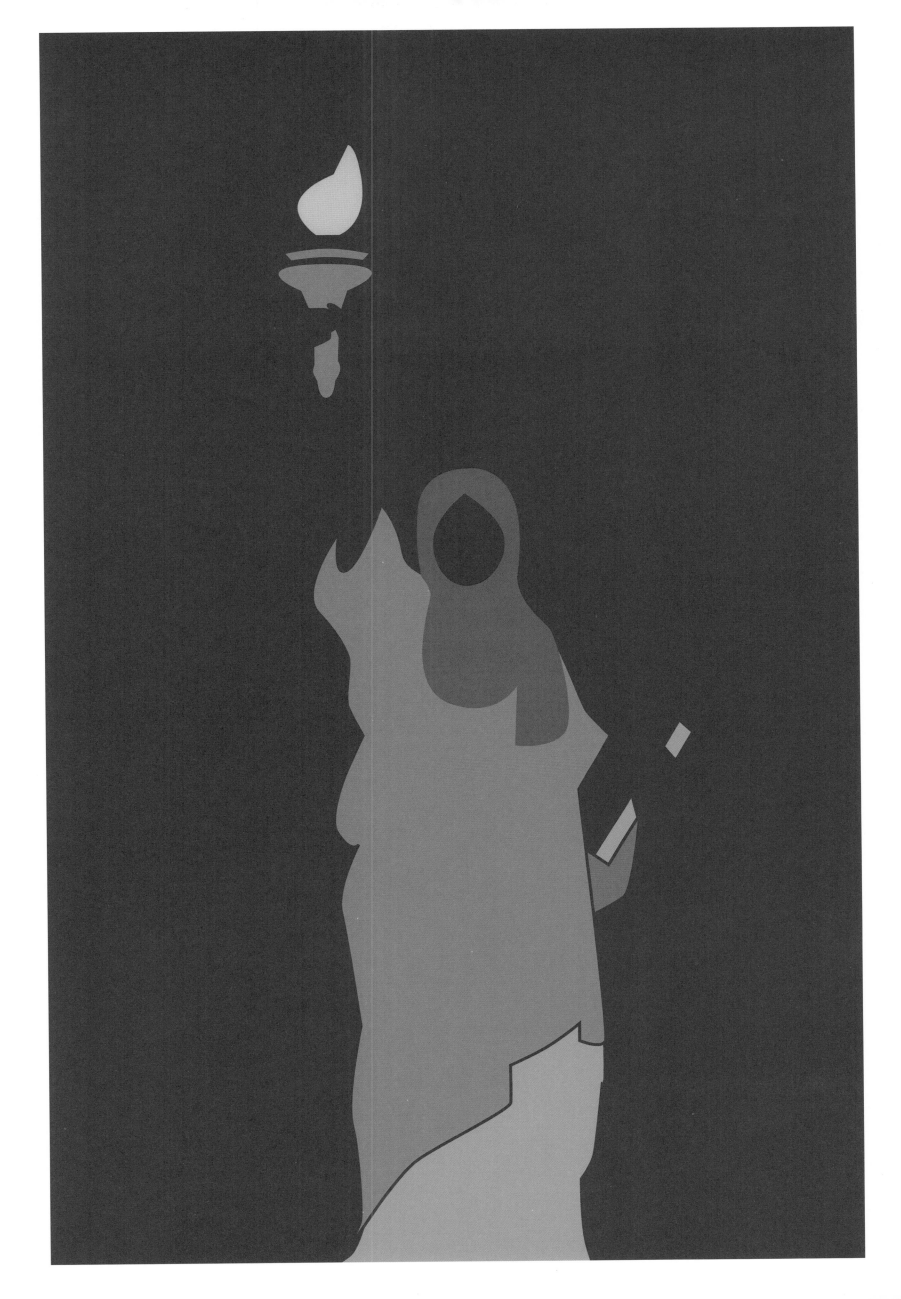

← IMMIGRANT LADY LIBERTY
Digital

Rajiv Fernandez
Brooklyn, NY, USA

Rajiv Fernandez is an architect and the author
of the children's books *Baby to Brooklyn* and
Baby to Big. He is the founder of Lil' Icon,
a company that makes stuff for your lil' one
or immature friend.

lil-icon.com

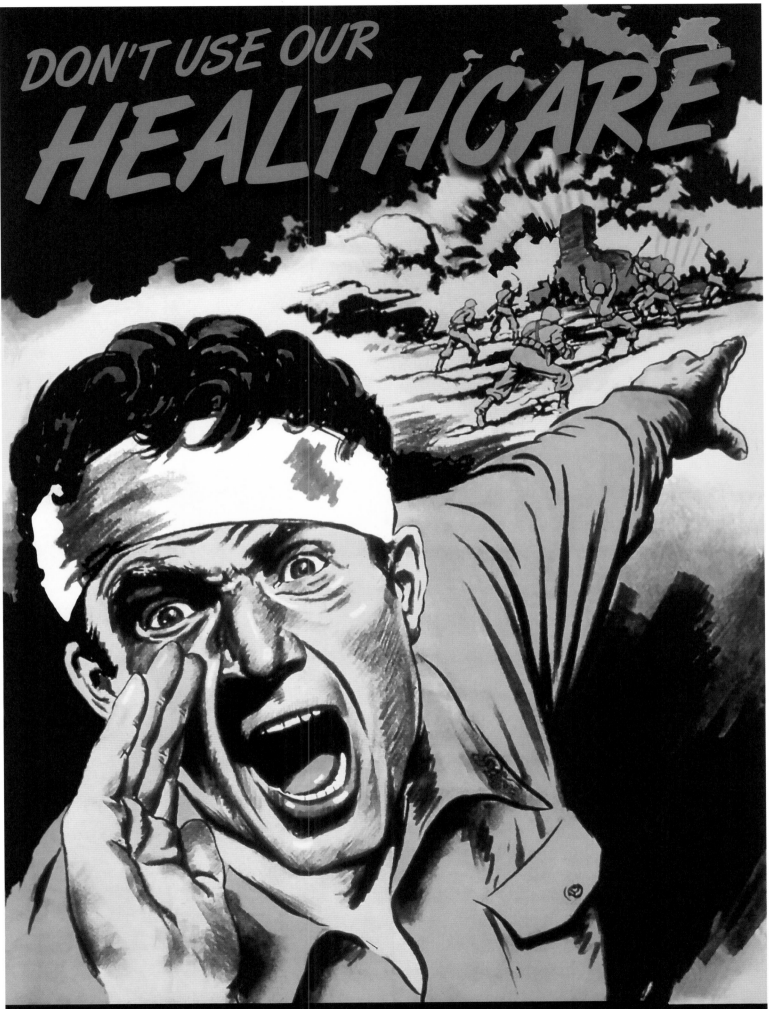

**DON'T USE OUR HEALTH CARE AS
YOUR POLITICAL BATTLEFIELD!**
Digital collage

Jeff Gates

Silver Spring, MD, USA

This design repurposes a rights-free World War II
poster entitled *More! More of Everything—
Quick*, which is archived by the National Archives.

Jeff Gates is an artist who works mostly under
the pseudonym Chamomile Tea Party. He remixes
old propaganda posters with new text and images,
sometimes pasting them up for commuters to
see on train platforms.

chamomileteaparty.com

← **CLIMATE CHANGE IS NOT A MYTH**
Digital

Elizabeth George
Tacoma, WA, USA

Elizabeth George studies media at the University
of British Columbia. She believes that we have
a responsibility to take care of our planet.

YOU ARE WELCOME HERE
YOU BELONG

← **YOU ARE WELCOME, YOU BELONG**
Screen print and letterpress

Globe Collection and Press at MICA

Baltimore, MD, USA

Founded in 1929, Globe Poster used fluorescent colors, bold wood type, and lettering to create posters promoting concerts, drag races, circuses, carnivals, and more. Globe ceased production in 2010, and the Maryland Institute College of Art (MICA) stepped forward to purchase a substantial portion of Globe's collection, including wood type, letterpress cuts, and posters. The acquisition by MICA keeps Globe's legacy alive as a working press, a teaching tool, and source for research.

Student interns at MICA assist with the design and production of new posters, printed on Globe Poster's press, as part of a hands-on learning experience. All of the new group's posters are in use on the MICA campus and in the surrounding Baltimore community.

globeatmica.com

 RESIST
Vintage wood type and cuts

Natalie Good
Brooklyn, NY, USA

Natalie Good prints designs primarily using
compositions set by hand. She often protests in
defense of animal rights, women's rights, and
environmental protection. She feels that political
design is a printer's duty.

etcletterpress.com

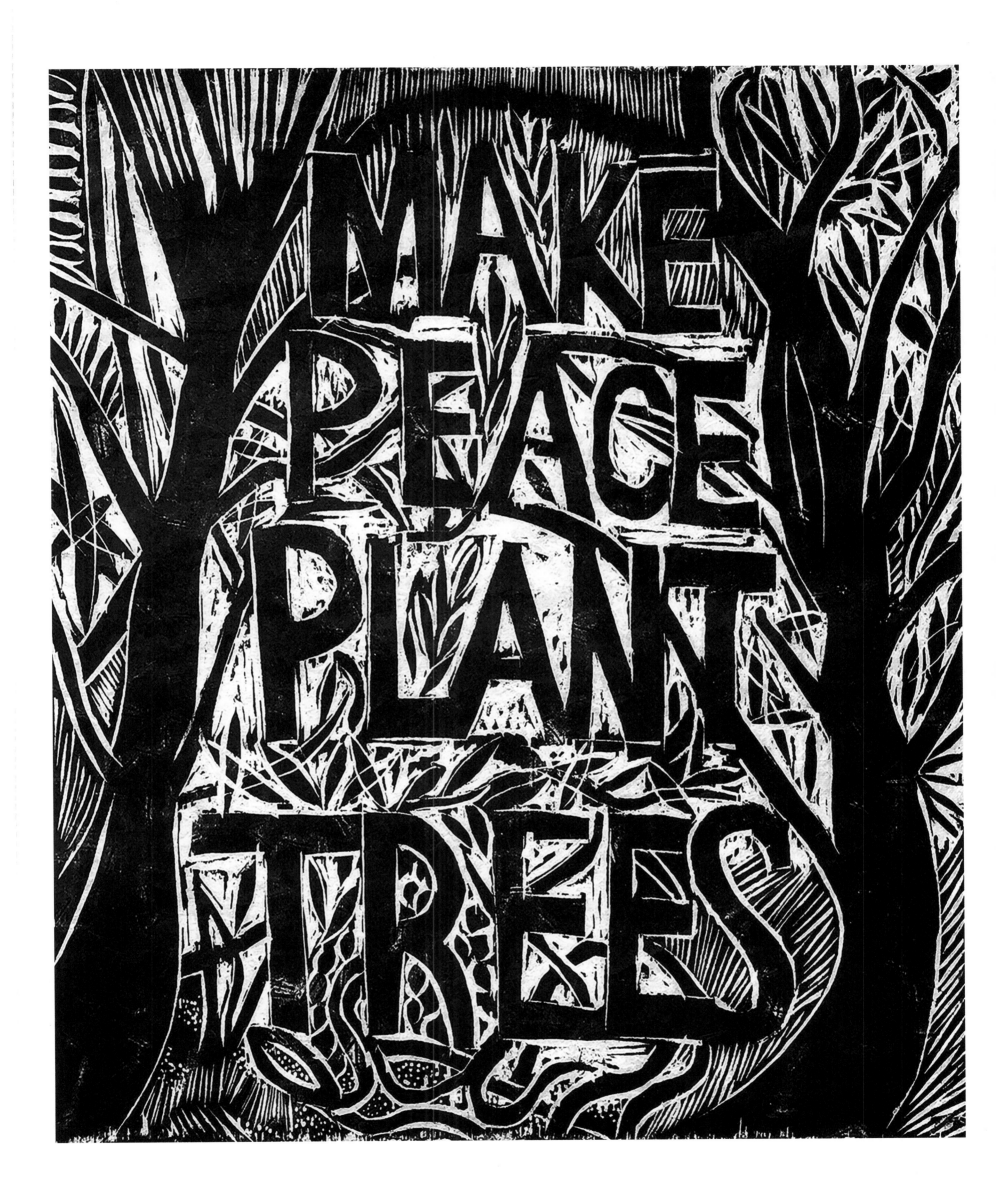

← **MAKE PEACE, PLANT TREES**
Woodcut print

Corey Hagelberg
Gary, IN, USA

Corey Hagelberg is the cofounder of the Calumet
Artist Residency along with his partner, Kate.
Centered in the Indiana Dunes, the residency
aims to promote the arts and connect people, art,
and nature in the Calumet Region. He currently
is a teacher at Indiana University Northwest,
and he maintains a studio practice focused
on black-and-white woodcuts and found material
assemblage.

coreyhagelberg.com

Medicine shouldn't be a *luxury*

← **NOT A LUXURY**
Digital

Valerie Joly Chock
Jacksonville, FL, USA

Valerie Joly Chock is student at the University of
North Florida, where she studies graphic design
and philosophy. She is from Panama City, Panama,
the place she calls home.

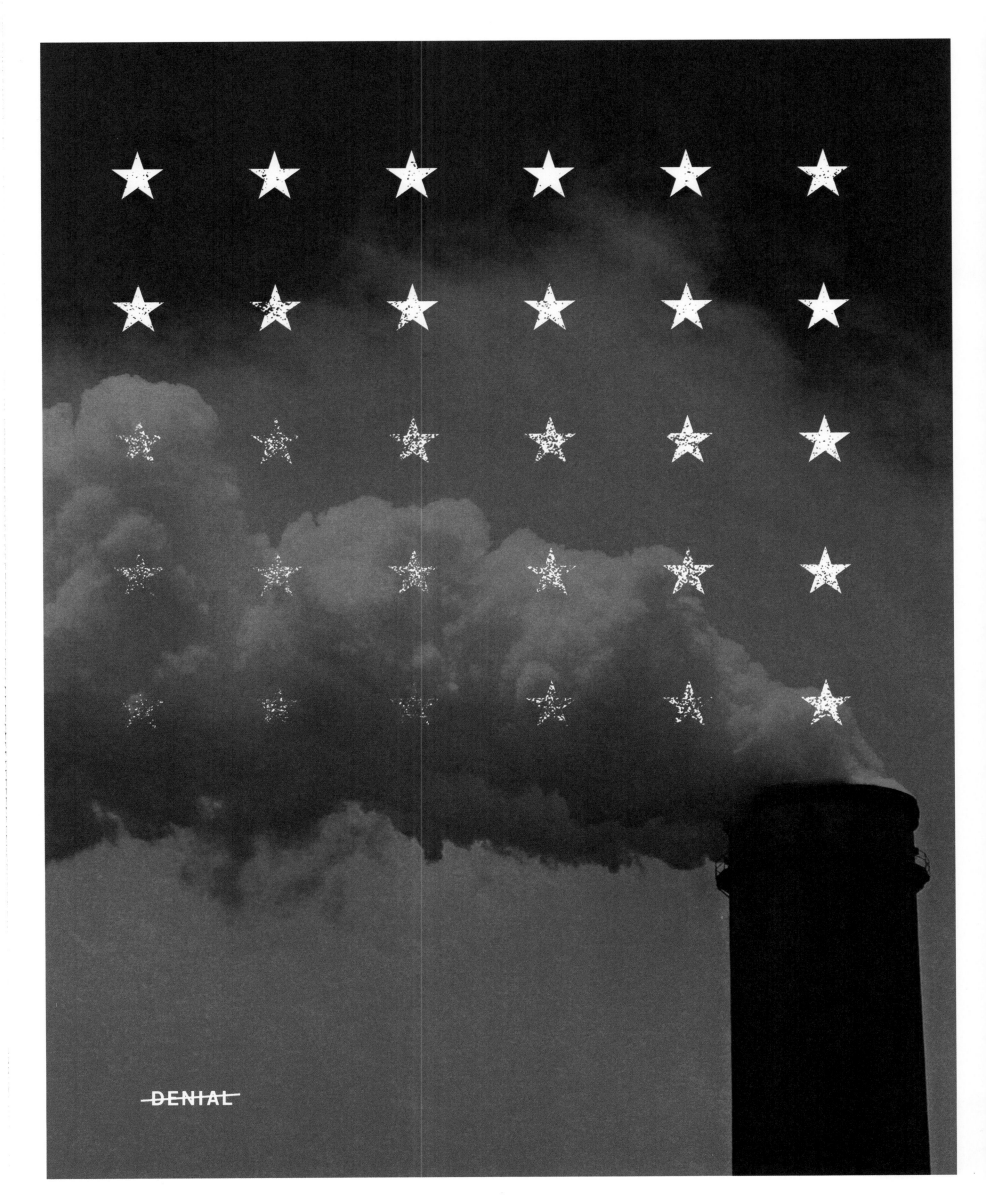

← **CLIMATE OF DENIAL**
Digital
(Background photograph by Aaron Schwartzbard)

Justin Kemerling
Omaha, NE, USA

Justin Kemerling is an independent designer,
activist, and collaborator focused on making
things beautiful, moving people to action, and
getting good things done. He works primarily with
community organizations, political campaigns,
and changemaking start-ups in need of branding,
graphic design, web design, and art direction.

justinkemerling.com

SMASH THE STATE

DECOUPLE

NETWORK

COOPERATE

DIVERSIFY

SYNERGIZE

CROSS BORDERS

MASTER PLAN

SUE

← **THE UNDERDOME GUIDE TO ENERGY REFORM**
Digital

Janette Kim and Erik Carver
Oakland, CA, USA

These illustrations first appeared in
The Underdome Guide to Energy Reform.

Janette Kim is an assistant professor at the
California College of the Arts, principal of
All of the Above, and founder of *ARPA Journal*.
Erik Carver is an architectural historian
at Columbia University Graduate School of
Architecture, Planning and Preservation, and
he focuses on conjunctions of architecture,
politics, and technology in the twentieth century.
They are the authors of *The Underdome
Guide to Energy Reform*.

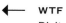 **WTF**
Digital photography

Keith Kitz
Boston, MA, USA

Keith Kitz is an artist, designer, and educator
living in Boston, Massachusetts. He is the
founder of Keith Kitz Design (formerly One Man's
Studio), and an adjunct professor at both the
School of Visual Arts at Boston University and
Boston Architectural College. Since 2014, he has
generated at least one poster a day—to date,
over two thousand posters—several of which
have traveled the world in exhibitions.

← **SEE AMERICA, CONSERVE AMERICA**
BAN FRACKING
Digitally altered drawing

Nicolas Lampert
Milwaukee, WI, USA

Nicolas Lampert is an interdisciplinary artist
and author whose work focuses on themes
of social justice and ecology. His artwork is in the
permanent collections of the Museum of Modern
Art and the Milwaukee Art Museum, among
others. He is the author of *A People's Art History
of the United States*.

nicolaslampert.org

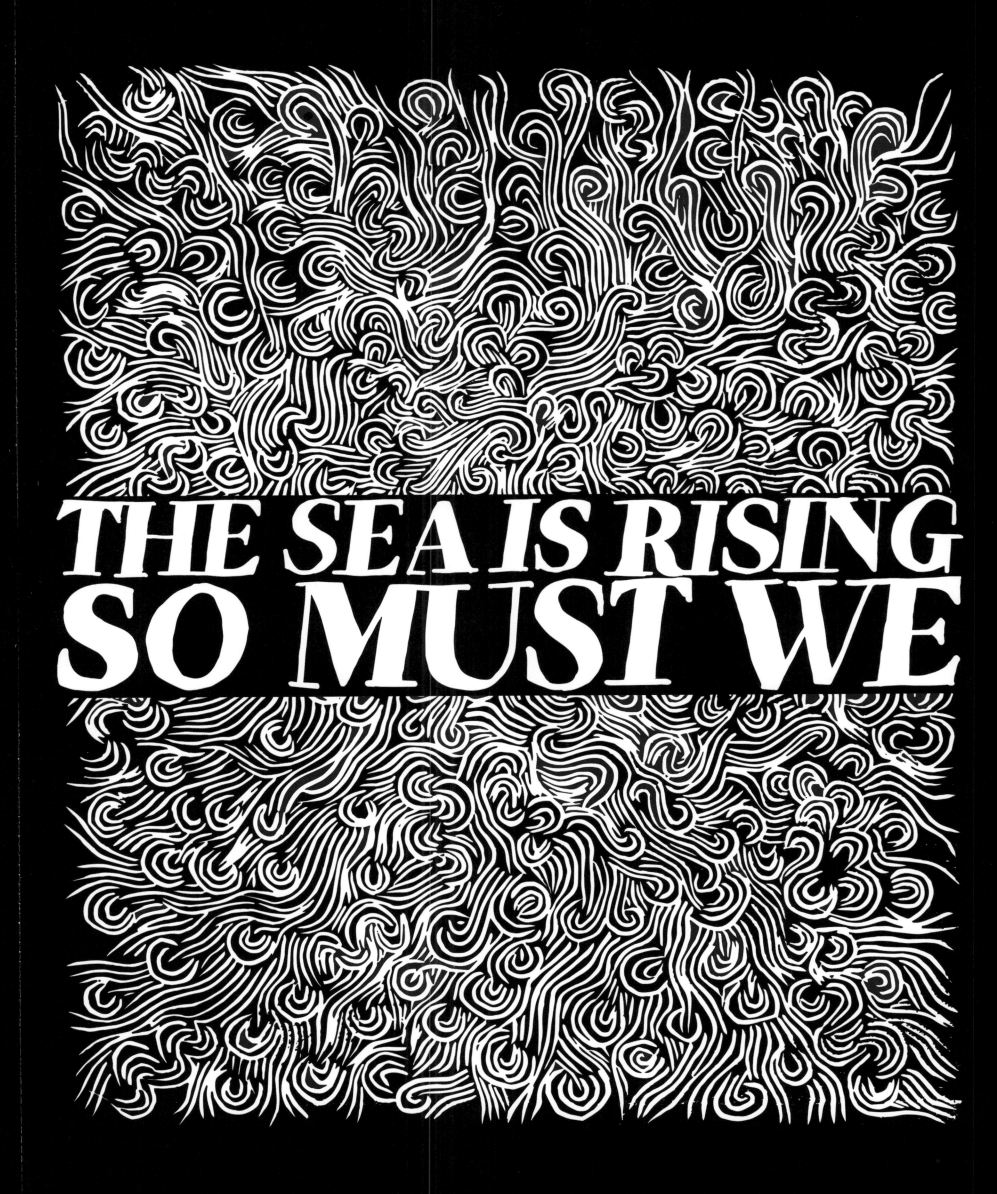

← **THE SEA IS RISING**
Relief print modified for screen printing

Janina A. Larenas
Santa Cruz, CA, USA

This design was originally screen printed with silver ink on black paper. It was inspired by designs that the artist saw during the March for Science on April 22, 2017.

Janina A. Larenas is a printmaker and book artist whose pieces range from stickers and posters to science illustration and embroidery. She is a founding member of Print Organize Protest and the Little Giant Collective—a letterpress, relief, and screen printing collective of artists.

littleisobel.com

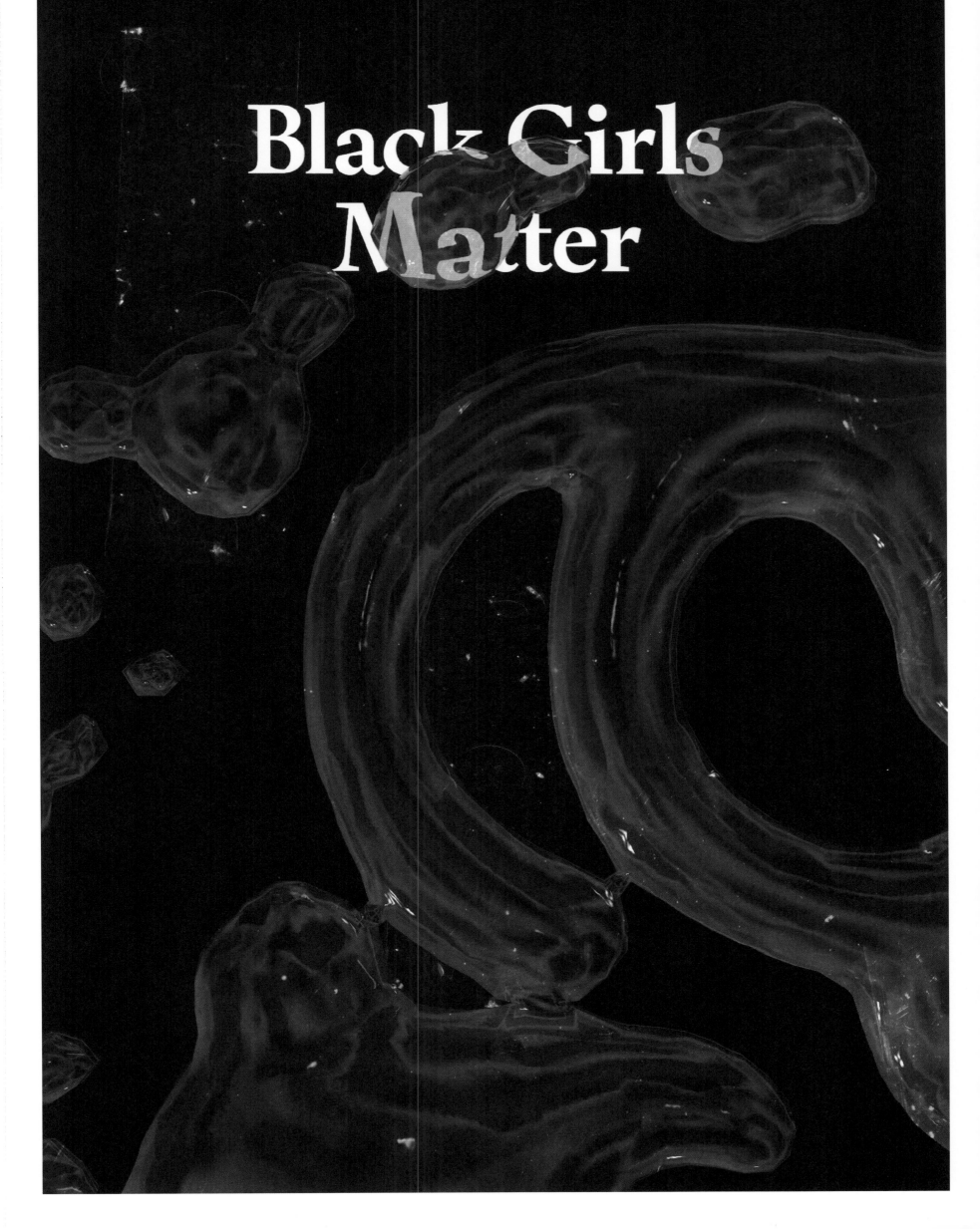

Black Girls Matter

← **BLACK GIRLS MATTER**
Digital

Iris Lee
Baltimore, MD, USA

This poster was commissioned by Shan Wallace,
a photographer, writer, and freedom fighter from
east Baltimore.

Iris Lee is a design major attending the Maryland
Institute College of Art. She believes that supplying
visual imagery for movements is a deeply vital,
difficult process. In an effort to acknowledge her
own perspective, she either creates work that
comments on aspects of her own identity, or she
collaborates with others.

irislee.co

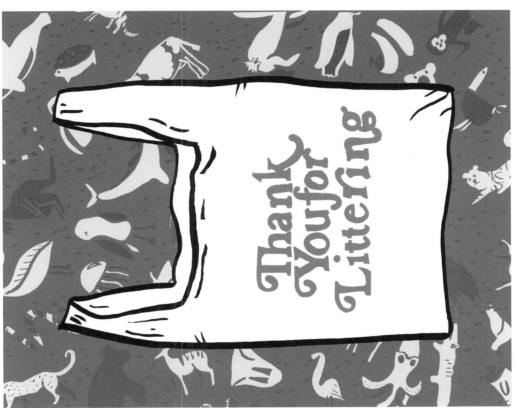

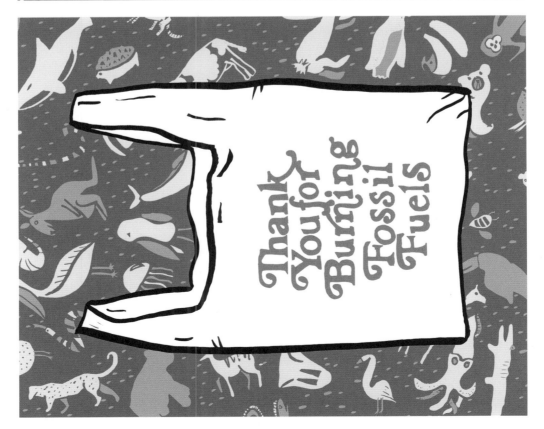

← **THANK YOU FOR…**
Hand-drawn type and original illustrations

Morgan Linnett
Starkville, MS, USA

In its first presentation the images of the plastic bags could be lifted to discover more information, thus encouraging viewer interactivity. Plastic bags contribute to our use of fossil fuels and destruction of habitats; the money used to clean up the litter could be better used. By bringing reusable bags while shopping, one person could remove twenty-two thousand plastic bags from the environment. So what are you waiting for?

Morgan Linnett studies graphic design at Mississippi State University. The environment is her passion, and she is doing what she can to ensure its survival through the generations.

morganlinnett.com

hold hand~~guns~~.

← **HOLD HANDS**
Digital

Alexis Lovely
Elk Grove, CA, USA

Alexis Lovely is a twenty-four-year-old multi-disciplinary designer, artist, and writer from the San Francisco Bay Area. She recently released her first book, *Quotable*, a collection of quotations and designs.

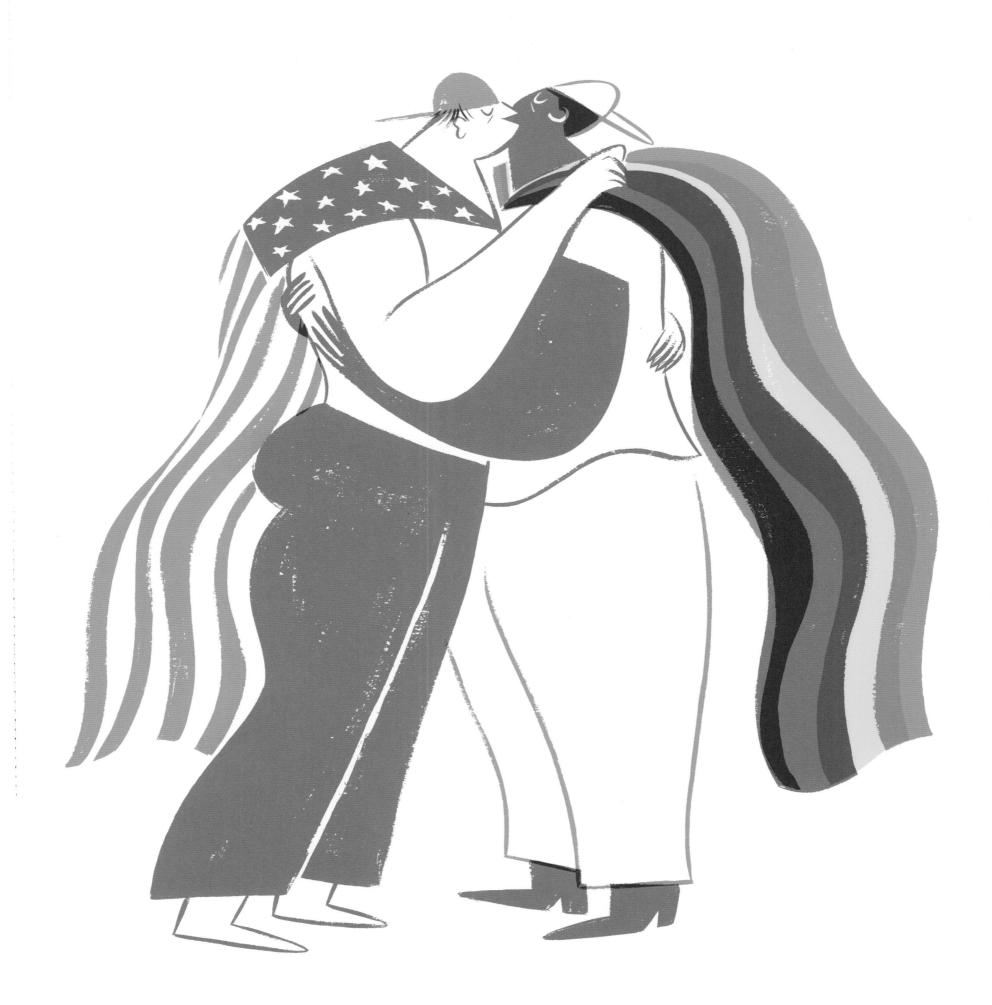

← **EMBRACE**
Digitally altered gouache and ink

Drew Lytle

San Francisco, CA, USA

Drew Lytle is a midwesterner with an incredible love for the outdoors and a doodling compulsion. When he was younger he spent a lot time watching cartoons, which fueled his appreciation for the silly and absurd. He believes that work without meaning becomes nothing more than an exercise in style.

drewlytle.com

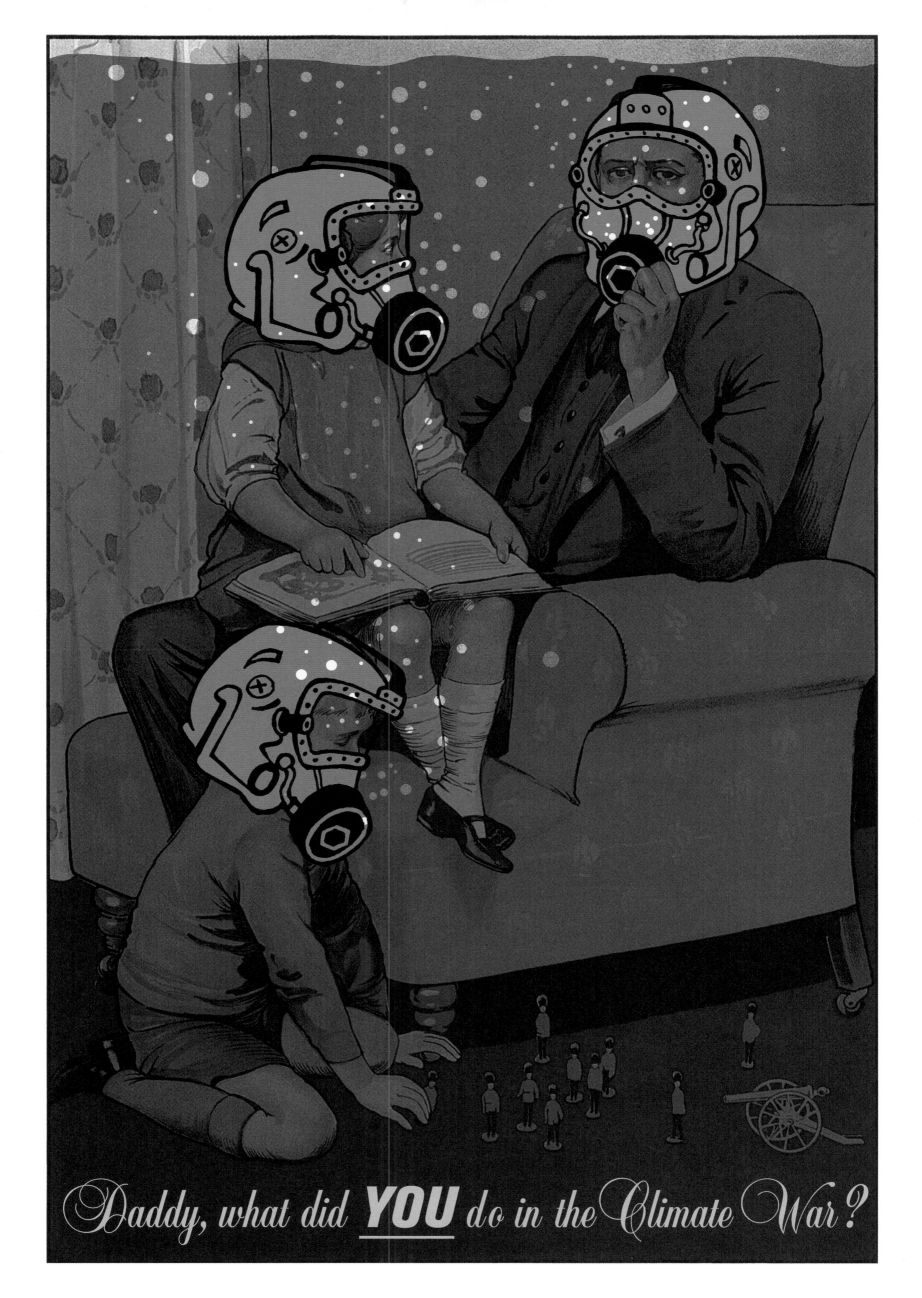

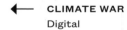 **CLIMATE WAR**
Digital

Josh MacPhee
Brooklyn, NY, USA

This design was originally commissioned by the Amplifier Foundation, and mass produced and distributed at the 2017 People's Climate March in Washington, DC. It repurposes a World War I British recruitment poster.

Josh MacPhee is a designer, artist, and archivist. He is a member of the Justseeds Artists' Cooperative, the co-author of *Signs of Change: Social Movement Cultures 1960s to Now*, and a co-editor of *Signal: A Journal of International Political Graphics and Culture*. He helps run Interference Archive, a public collection of cultural materials produced by social movements.

justseeds.org

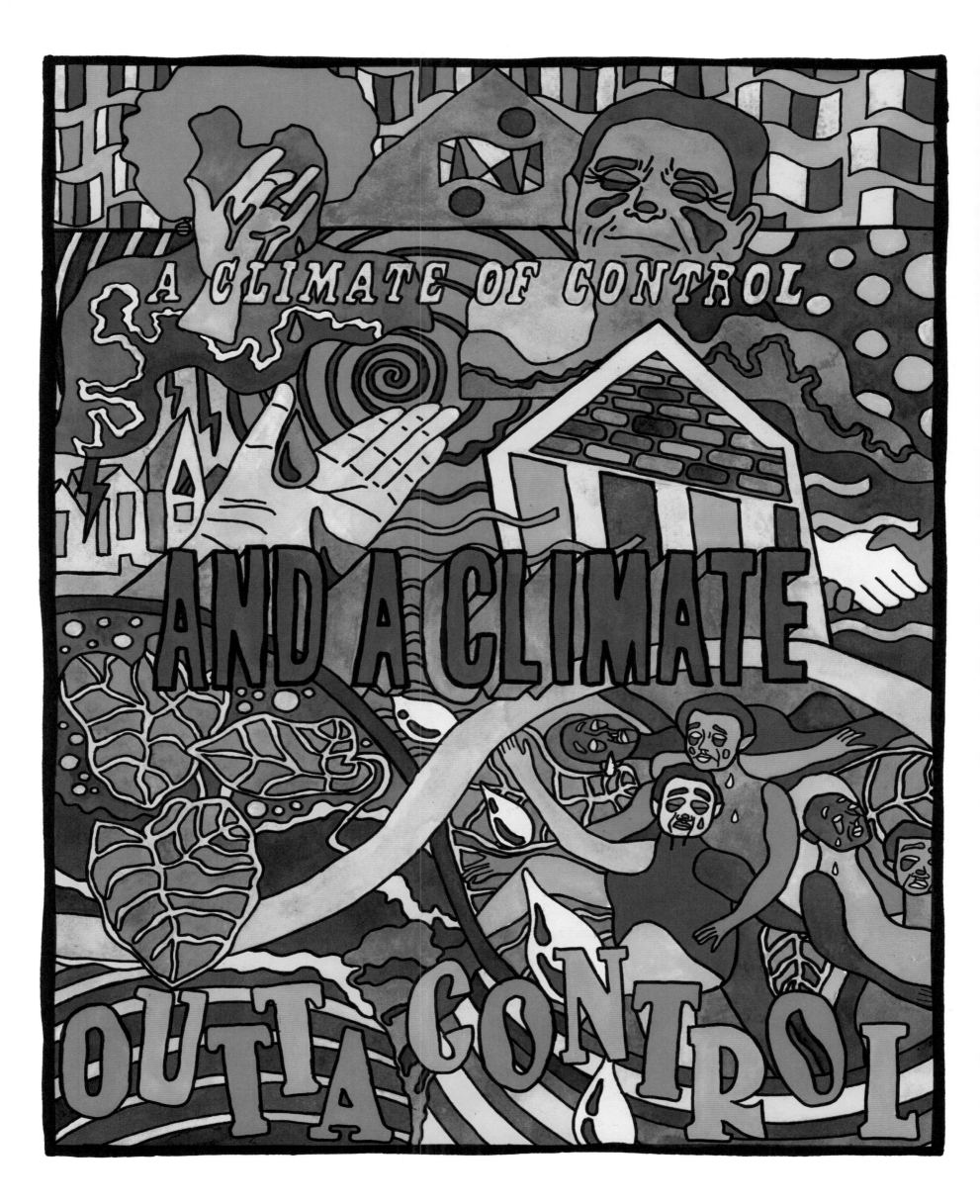

← **A CLIMATE OF CONTROL AND**
A CLIMATE OUTTA CONTROL
Watercolor and ink

Nicky Minus

Sydney, Australia

Nicky Minus is a comic book artist whose brightly
colored work centers on sex, shame, and feminism.

nickyminus.com

DISMANTLE
ABOLISH
ERADICATE
DESTROY
CRUSH THE
PATRIARCHY

← **DISMANTLE, ABOLISH, ERADICATE,
DESTROY, CRUSH THE PATRIARCHY**
Digital lettering

Nicholas Misani
New York, NY, USA

Nicholas Misani is a designer and letterer
who is currently working at Louise Fili Ltd.
He began his formal training in architecture
and industrial design in Italy and continued his
studies in Japan and the United States.
He is passionate about period typography,
decorative arts, and crafts.

misani.com

← **PROTECT CIVIL LIBERTIES**
Digital

Wael Morcos
New York, NY, USA

The Arabic text is a translation of the English
text. This design was selected in the 100
Best Arabic Posters competition in Cairo, Egypt.

Wael Morcos is a graphic designer originally
from Lebanon who uses typography to investigate
the formal qualities of words and their complex
meanings. He is also interested in the moments
where communication fails and uses its short-
comings to mine new ways to reach out and to
tell stories.

waelmorcos.com

PRISON

If you want to know how many prison cells to build look at the number of third graders who can't read

← PRISONS
Digital typography

Hamid Nasr
Isfahan, Iran

Hamid Nasr is a twenty-four-year-old graphic
designer. He recently graduated from the Islamic
Azad University, where he studied software
engineering.

← **LEVÁNTATE (RISE UP)**
Screen print

Marisol Ortega
Kansas City, MO, USA

This poster was originally included in the
Hello Poster Show, a Seattle-based pop-up
fundraising exhibition featuring silkscreened
posters created by designers and artists
from around the world.

Marisol Ortega is a freelance designer and
a senior designer for Hallmark Cards. She is
a multifaceted illustrator, pattern maker, and
lettering expert who often uses bright colors.

marisolortega.com

The production of new TYPEFACES is only a NECESSITY under capitalism*

* LETTER TSCHICHOLD TO ALBERS, 8 DECEMBER 1931.

WHERE ADVERTISING IS TRANSFORMED INTO SCIENTIFIC
COMMUNICATION (IN SOCIALISM) THE TYPEFACE
NONESENSE IS POINTLESS.

IBID.

IF YOU WANT TO GET RID OF INDIVIDUALISM IN THE
NATURE OF PUBLICITY, THEN IT IS NOT ENOUGH TO REPLACE
AXIAL ARRANGEMENTS WITH ASYMMETRY, FRAKTUR WITH
SANSERIF TYPEFACES, DRAWINGS WITH PHOTOS, AND
ORNAMENT WITH A SUPPOSED FUNCTIONAL GEOMETRY
IN DESIGN. TO THAT END YOU MUST, FOR BETTER OR
WORSE, THROW OUT THE BABY WITH THE BATHWATER AND
DENY ABSOLUTELY ALL CAPITALIST PUBLICITY, ROOT AND
BRANCH.

WHILE PRIVATE COMMERCE REMAINS IN EXISTENCE, THEN
IT IS BETTER FOR IT TO REMAIN RECOGNIZEABLE AS SUCH.

ANONYMOUS REVIEW OF DIE NEUE TYPOGRAPHIE IN
BAUHAUS, JG.3, NR. 2, 1929.

OTHER FORMS PUBLISHING, LOS ANGELES, 2017.

← **THE PRODUCTION OF NEW TYPEFACES
IS ONLY A NECESSITY UNDER CAPITALISM**
Screen print

Other Forms
Chicago, IL, USA

The headline on this poster is from a letter
Jan Tschichold wrote to Josef Albers,
a translation of which appears in Christopher
Burke's *Active Literature: Jan Tschichold and
the New Typography*. The poster is meant to
dialectically pose the political problem of
typographic form under capitalism. It debuted
at the LA Art Book Fair in February 2017.

Other Forms, organized by Jack Henrie Fisher,
Jonathan Krohn, and Alan Smart, is a mobile
research and design collective working in multiple
intersections of architecture, graphic design,
and publishing. Other Forms considers how design
reflects and critiques the material and social
conditions of its practice in semi-autonomous
marginal spaces.

otherforms.net

← **RACIST SYSTEM**
Linoleum blockprint
(Originally commissioned by the
Amplifier Foundation)

Roger Peet
Portland, OR, USA

Roger Peet is a printmaker, a founding member
of the Justseeds Artists' Cooperative, and
a leader of the Flight 64 Community Print Studio.

toosphexy.com

Blue for a boy.

Pink for a girl.

Green for a boy.

Purple for a girl.

Yellow for a boy.

Red for a girl.

Orange for a boy.

Turquoise for a girl.

White for a boy.

Black for a girl.

Pink for a boy.

Blue for a girl.

← **GREEN FOR A BOY…**
Digital

Ian Perkins
Zhubei City, Taiwan

Ian Perkins is a British designer who leads
Name&Name, an international branding
and graphic design firm. His work has won
an award from Art Directors Club USA,
and appears in the permanent collection
of the Smithsonian Museum.

ianperkinscreative.com

SANCTUARY

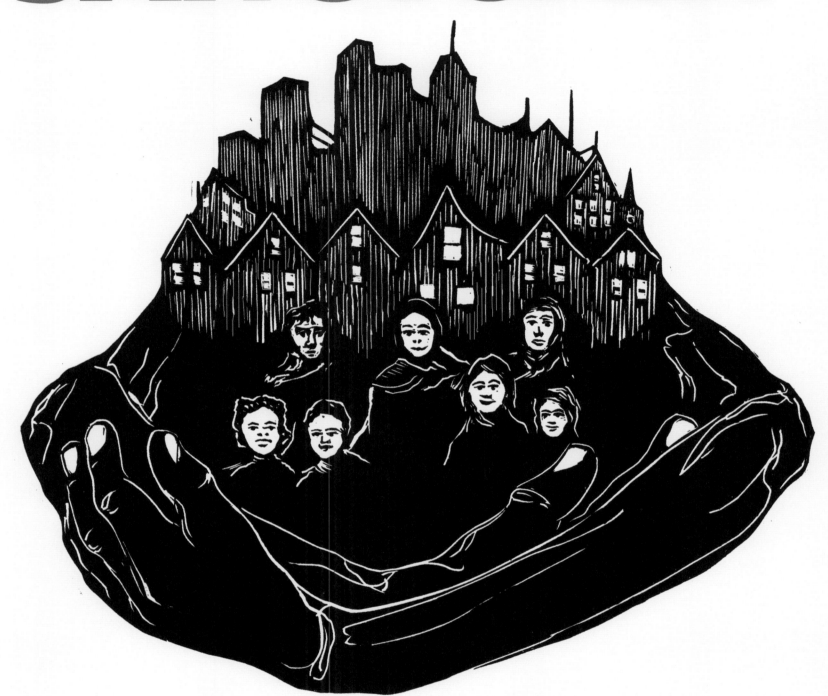

CITIES
NOW

← **SANCTUARY CITIES**
Linoleum and digital print

Pete Railand
Milwaukee, WI, USA

Pete Railand is a printmaker and traveler who
grew up in the rural Northwoods of Wisconsin.

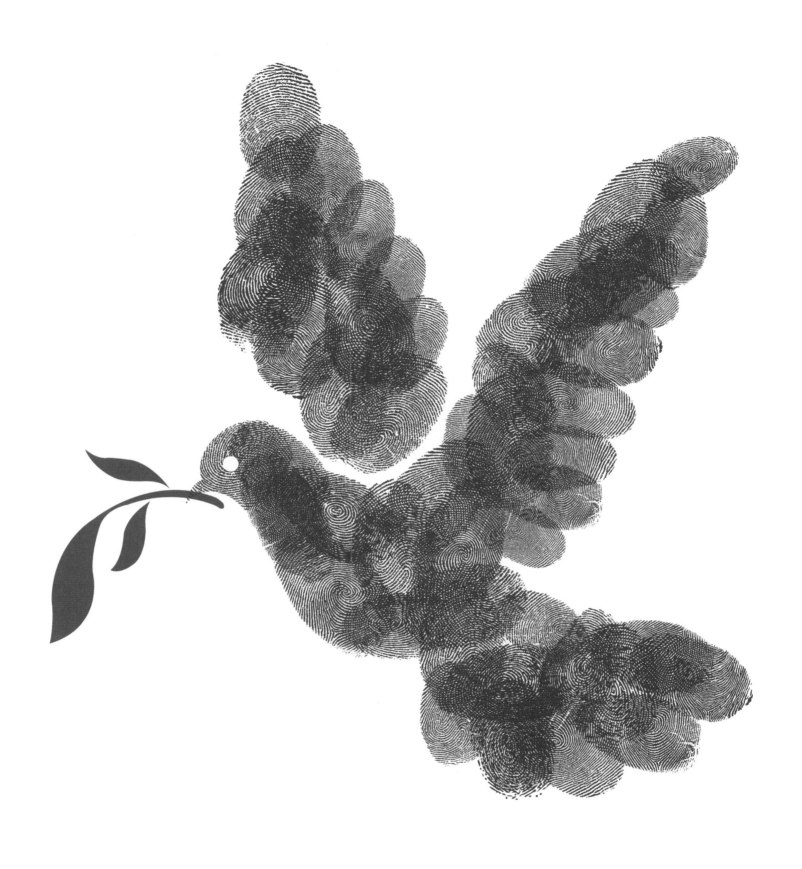

Vote for peace

← VOTE
Digital

Ali Romani
Tehran, Iran

Ali Romani studies graphic design at Azad
Islamic University of Yazd.

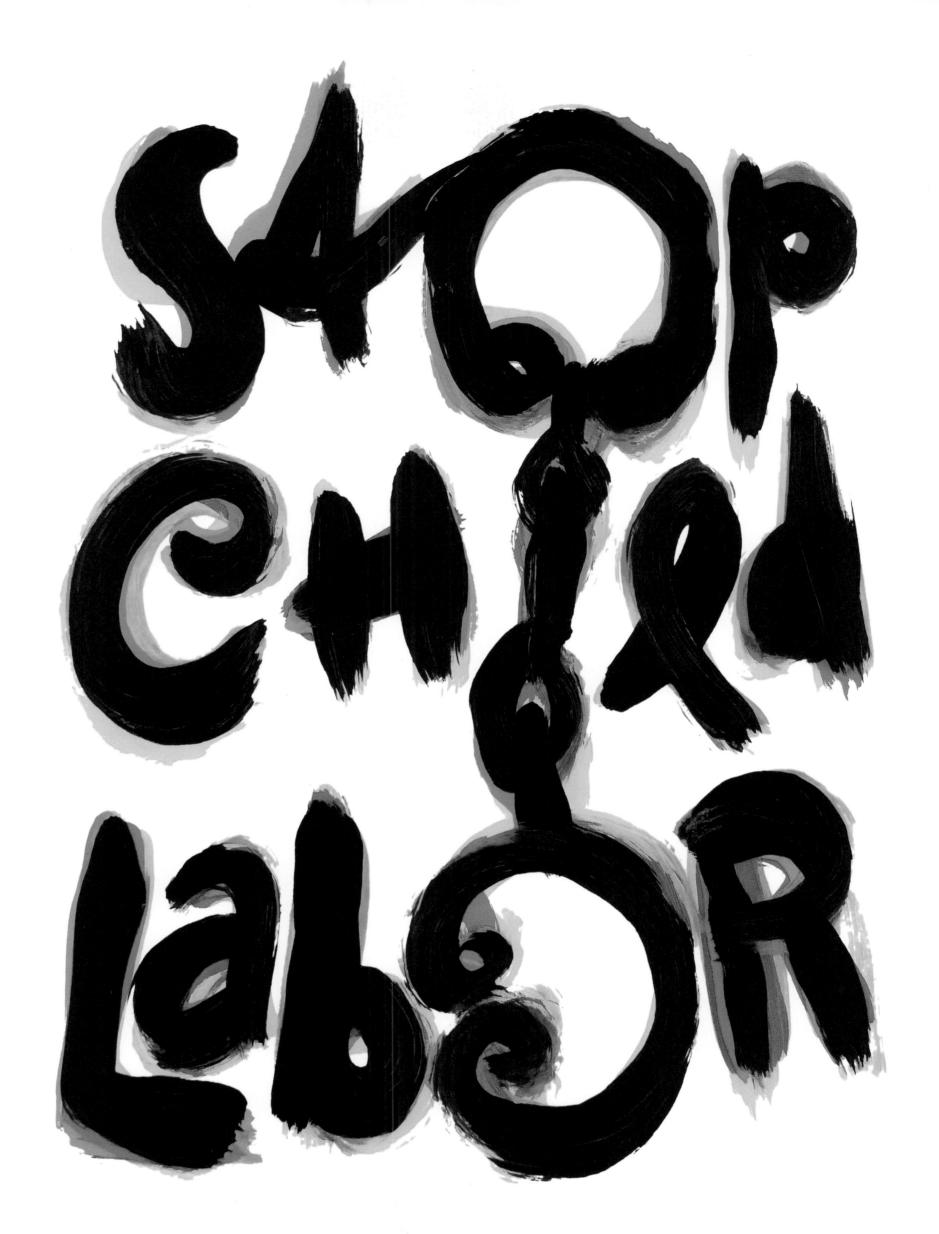

← **STOP CHILD LABOR**
Digitally altered paint

Jan Šabach
Northampton, MA, USA

Jan Šabach is a Czech-born graphic designer
whose studio, Code Switch, imagines a meaningful
connection between the message and the viewer.

jansabach.myportfolio.com

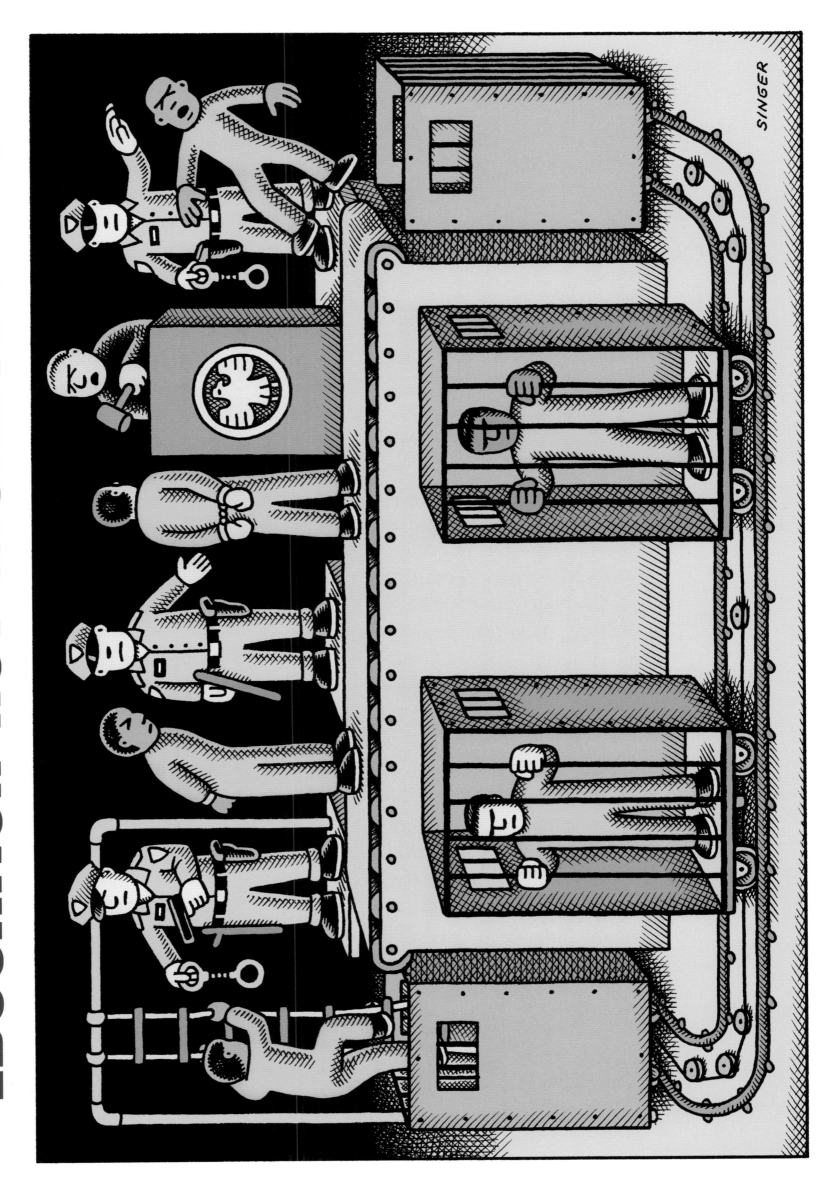

EDUCATION NOT INCARCERATION
Digitally altered pen and ink
(Originally posted on the cartoon bank
PoliticalCartoons.com)

Andy Singer
Saint Paul, MN, USA

Andy Singer has been drawing cartoons and
illustrations for over twenty-five years. He is the
author of four books, and his comics have been
published in the *New Yorker*, the *New York Times*,
the *Washington Post*, and many others.

andysinger.com

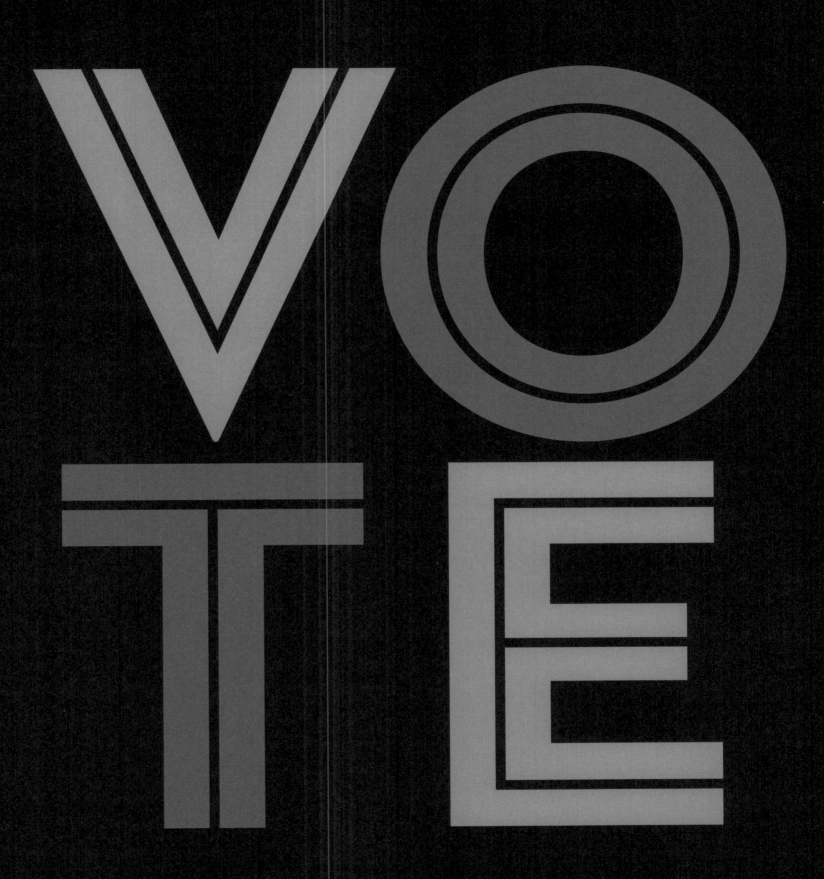

← **VOTE WISELY**
Digital
(Created for Get Out the Vote, a campaign
hosted in 2016 by AIGA, the professional
association for design)

Claude Skelton

Towson, MD, USA

Claude Skelton has headed Skelton Design,
a graphic design and branding firm specializing in
higher education and the arts, for over thirty
years. He has frequently served as a judge for
CASE awards competitions. National recognition
includes awards from the Society of Publication
Designers, Communication Arts, CASE, UCDA, the
New York Art Director's Club, *Critique Magazine*,
the Type Director's Club, *Print Magazine*,
AIGA-Baltimore, and the Washington Art
Directors Club. He currently teaches graphic
design at Towson University.

skeltondesign.com

das
kapital
hill

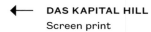 **DAS KAPITAL HILL**
Screen print

Slavs and Tatars

Slavs and Tatars is an art collective devoted
to an area east of the former Berlin Wall and west
of the Great Wall of China known as Eurasia.
Its practice is based on three activities: exhibitions,
publications, and lecture-performances. The group
has exhibited in major institutions internationally,
including MoMA, New York; Secession, Vienna;
Kunsthalle Zürich; Tate Modern, London; the tenth
Sharjah Biennial, the eighth Berlin Biennial, and the
ninth Gwangju Biennial. The collective has published
eight books, including *Friendship of Nations: Polish
Shi'ite Showbiz* (Book Works, 2013), *Mirrors for
Princes* (JRP-Ringier, 2015), and its translation of
the legendary Azeri satire, *Molla Nasreddin*,
currently in its second edition with I. B. Tauris.

slavsandtatars.com

HUMANITY

← **HUMANITY**
Screen print
(Originally created in a limited edition of
fifty prints by the artist)

Chuck Sperry
San Francisco, CA, USA

Chuck Sperry is an American artist, illustrator,
and rock music poster designer, recognized for his
luminous silkscreen prints. Since 2012 he has
been the owner of Hangar 18, a silkscreen print
studio located in Oakland, California.

chucksperry.net

I AM A WOMAN

I AM A WOMAN NOW WATCH ME VOTE

← **I AM WOMAN**
Digital

Elizabeth Sprouls
Towson, MD, USA

Elizabeth Sprouls is a principal at Skelton Design
and has been the lead designer on projects for
higher education and museums. During her time
in Boston, she produced work within Harvard
Public Affairs and Communications. Prior to
that, she managed and designed nationally
recognized museum exhibitions. She currently
teaches a graduate publication design course
at Maryland Institute College of Art.

skeltondesign.com

← YAY, NAY
Screen print

Studio Matthews

Seattle, WA, USA

This poster was originally included in the
Hello Poster Show, a Seattle-based pop-up
fundraising exhibition featuring silkscreened
posters created by designers and artists
from around the world.

Studio Matthews designs exhibitions, install-
ations, signage, brands, print materials,
websites, and campaigns. The studio believes
that sustainable design is not just a matter
of minimizing environmental impact, but
a responsibility to educate its audience
to think and act differently.

studiomatthews.com

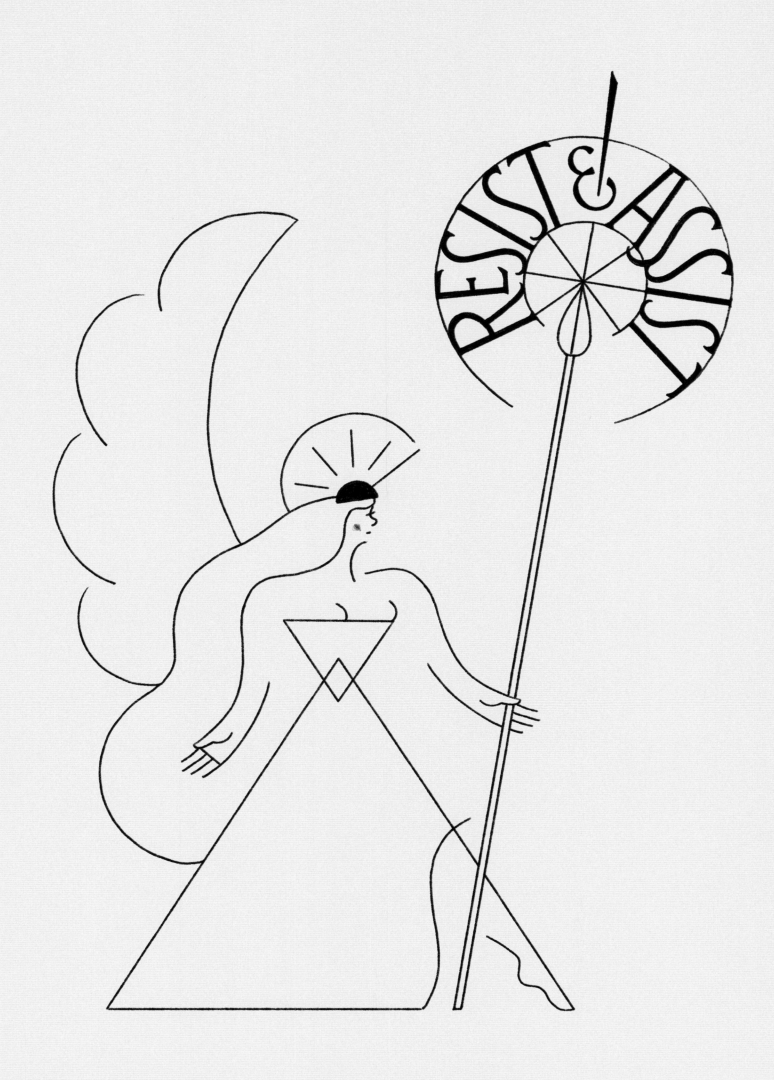

Digitally altered ink drawing

Kelly Thorn
Brooklyn, NY, USA

Kelly Thorn is a graphic designer specializing
in illustration. With her husband, Spencer Charles,
she runs a small studio in the Pencil Factory,
a building shared by independent designers.
She and Spencer met when they worked together
at Louise Fili Ltd.

charlesandthorn.com

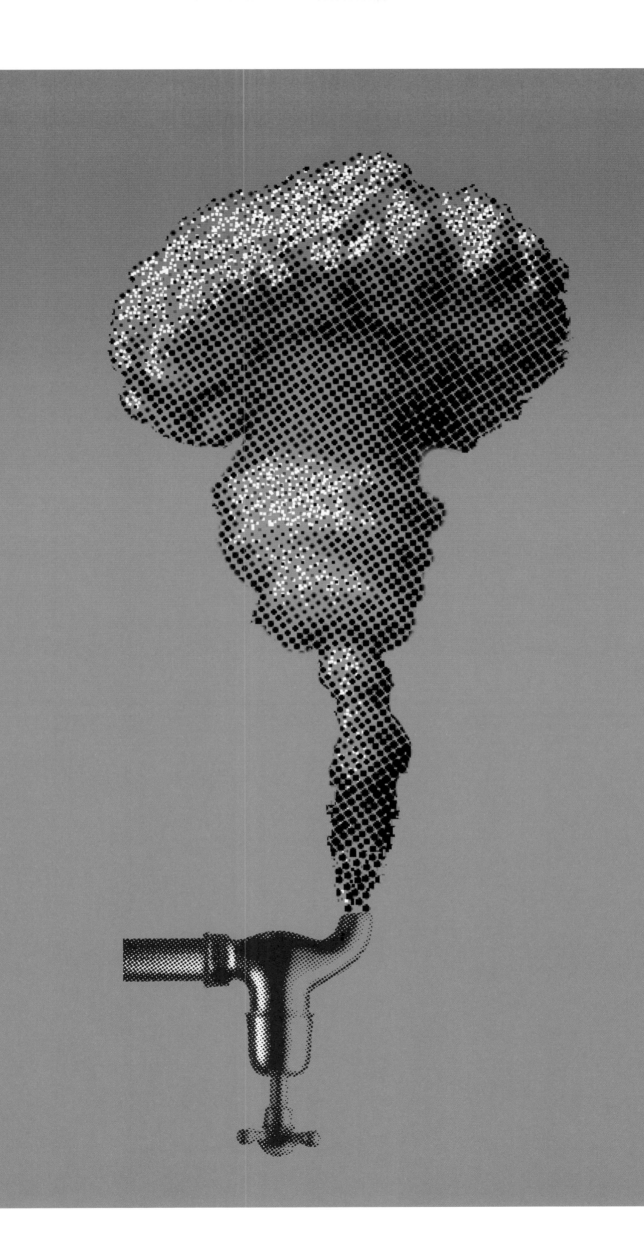

Shangning Wang
New York, NY, USA

Sangning Wang is an award-winning poster
designer from China.

shangning.myportfolio.com

← **STAND UP NOW**
Paper collage

Stephanie Wunderlich
Hamburg, Germany

Stephanie Wunderlich works as a freelance
illustrator for international magazines and book
publishers. Her favorite medium is paper collage—
she uses both digital and analog techniques
like scissors and glue. She has received awards
from Art Directors Club Germany, American
Illustration, and *3x3* magazine. Stephanie is
a member of the female artist collective Spring,
which publishes an annual anthology of comics,
illustrations, and drawings.

wunderlich-illustration.de

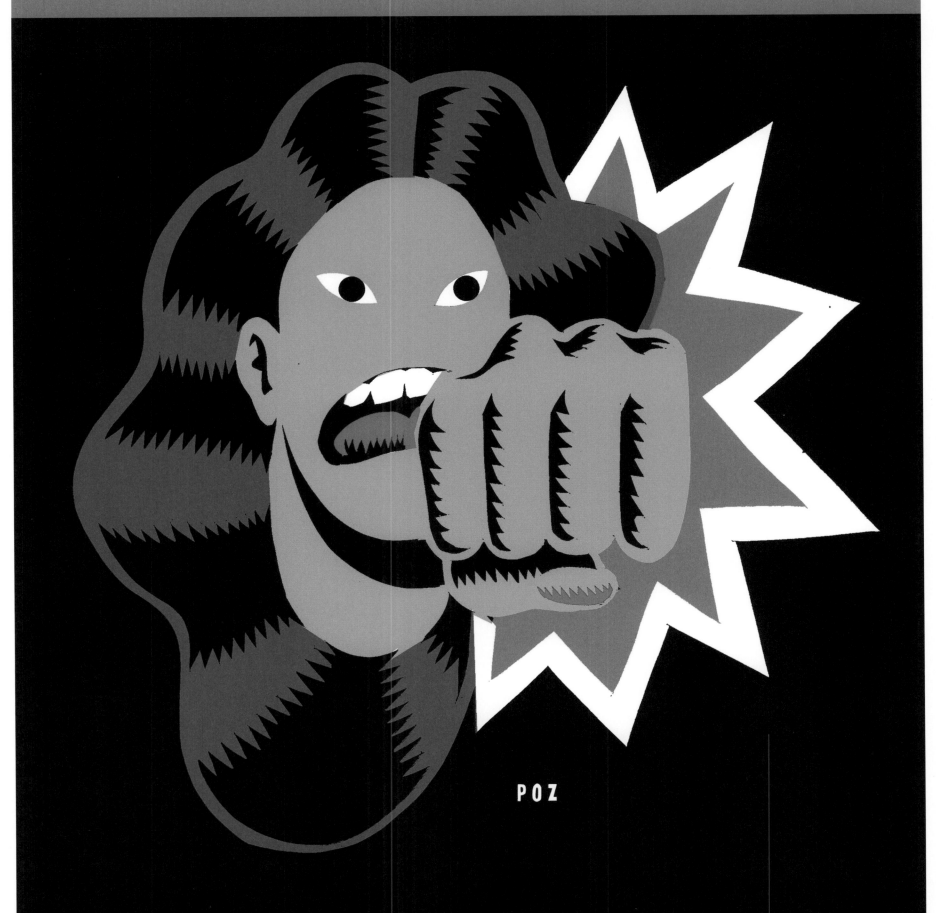

← **AND NEVERTHELESS SHE PERSISTED**
Paper cut art

Peter O. Zierlein
Northampton, MA, USA

This design was first published in *Resist!*,
a political comics publication. It was inspired
in 2017 when the US Senate voted to silence
Senator Elizabeth Warren's objections to
confirmation of Senator Jeff Sessions as US
Attorney General. Senate Majority Leader
Mitch McConnell uttered this sentence during
comments following the vote in an effort
to defend the Senate's actions and blame
Senator Warren.

Peter O. Zierlein is a German paper cutter
and illustrator who creates artwork for the
New York Times, the *Washington Post*,
the *LA Times*, *Spiegel*, *Stern*, *Berliner Zeitung*,
and others. He also designs patterns for
the paper industry and paper-cut collages for
hospitality services and interior decorators.

peterozierlein.com

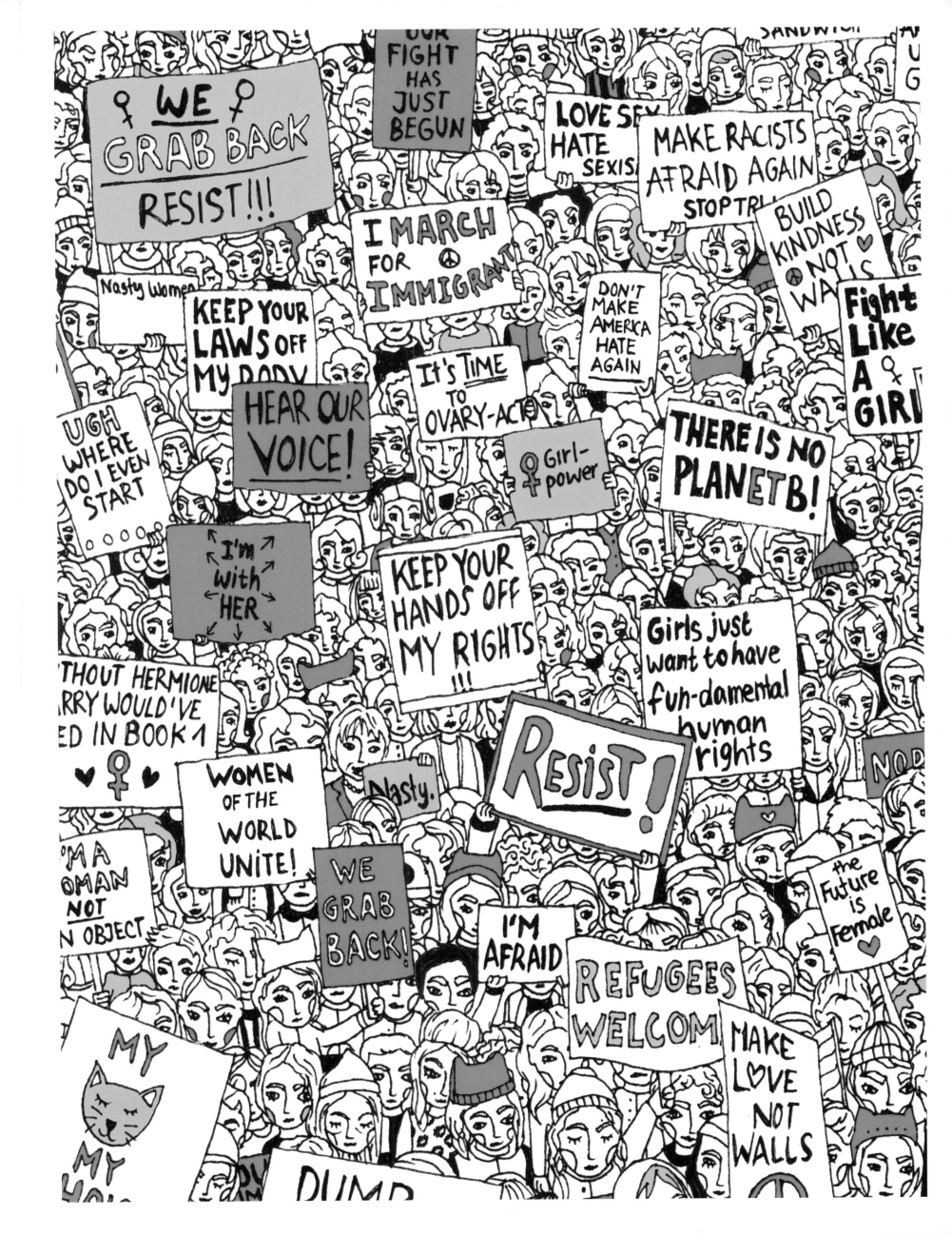

RESIST!
Digitally altered felt-tip pen drawing
(First published in *Resist!*, a political comics
publication)

Jolanda Olivia Zürcher
Tübingen, Germany

Jolanda Olivia Zürcher is an eighteen-
year-old art student.

jolandaolivia.wordpress.com

Afterword:
Resistance in an Image Culture

—

Avram Finkelstein

In much the same way the assassination of Archduke Franz Ferdinand in 1914 set the political events of the entire twentieth century into motion, the 2016 American election will undoubtedly trigger consequences for the twenty-first. Its impact is so significant we will likely be studying it for the next hundred years, and for activists and artists, it serves as a meaningful signal post to those of us who have dedicated our lives to communicating ideas in our shared social spaces, propagandists like myself.

Hackles sometimes go up when I use the word *propaganda* to describe the work of the Silence = Death and Gran Fury collectives, but that is how we thought about our work-product. I helped found these two political poster collectives that produced many of the works most closely associated with the AIDS activist organization, the AIDS Coalition To Unleash Power (ACT UP). Because propaganda is often seen as a strategy of manipulation serving institutional power structures, many grassroots activists prefer not to think of their own agency this way. However, propaganda was the driving motivation behind images like *Silence = Death*, and it might be useful to consider this now, since the right-wing media machine also uses images and text to manipulate ideas, and as such, is also propagandist. Where right-wing media and the Silence = Death collective diverge, of course, is in the latter's resistance of institutional power, proving that appeals to political agency can use the language of capital, i.e. advertising, and still resist its mechanisms.

Speculation replaced commodity decades ago, and our world is now an investment economy. We currently speculate in content, as anyone who has been sucked into our 24/7 internet slipstream can attest. Content is delivered through increasingly sophisticated algorithms that insert commercial messages based on our habits and preferences into most of our social media platforms. Trump might be president, but content is king, and our treasure is now hackable information—the spoils of half a century of combined Russian and American surveillance oligarchies—delivered to us through some of the same devices that brought us the Kardashians. Trump, a former reality television star, has more in common with Taylor Swift than he does with Paul Ryan.

And there's the rub. The internet is a densely layered folktale gone wild, a twenty-first century throwdown between those who subsidize commercial storytelling in our social media spaces, and those of us these stories theoretically depict. So staging public discourse in late-stage capitalism is to be trapped in a skirmish between content and form, along the increasingly permeable border between our shared social spaces and the images we use to represent them. Every single digital native gets it.

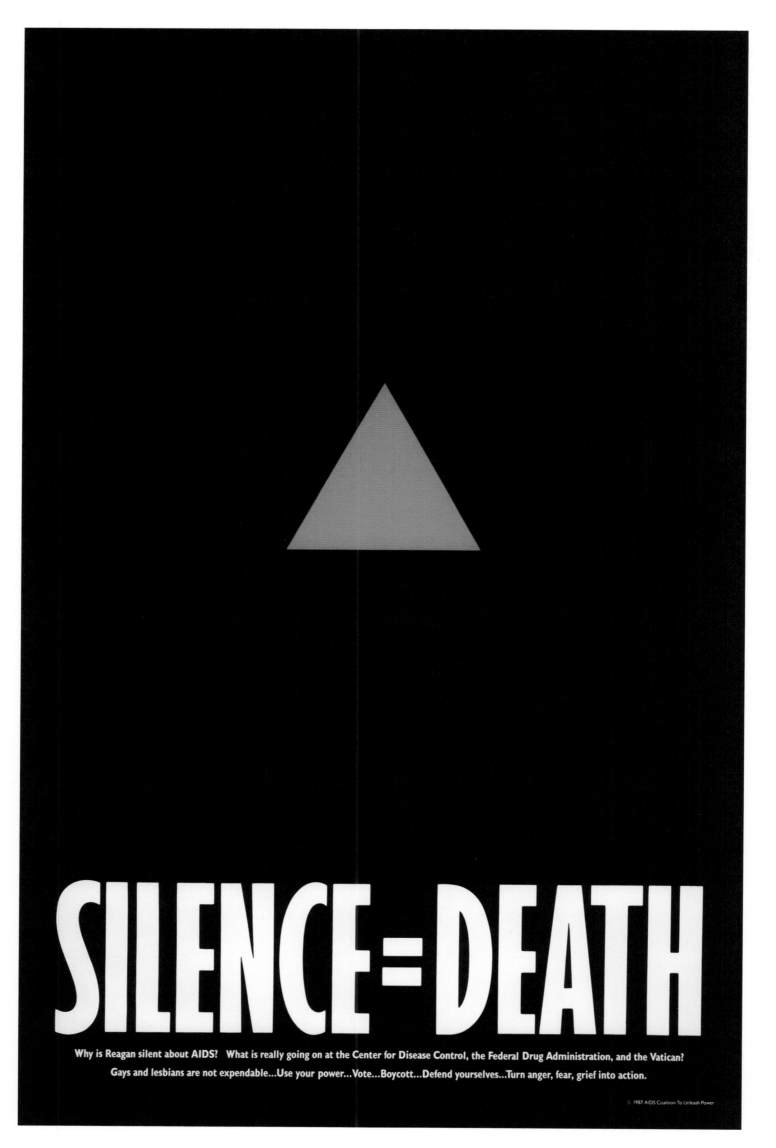

Silence = Death, Silence = Death Project, 1987, poster, offset lithography.

From an organizing perspective, we the Resistance understand propaganda too, but we haven't yet learned to harness it the way that right-wing media has. When we focus solely on the degradation of fact-based truth, we do it at our own peril, because that cow left the barn before right-wing populism took over, and popular culture morphed into a narrative of power a long time ago. The Resistance understands pop culture to be a power narrative, but after decades of commercial interests squatting on the American identity through information technologies, most audiences do not, and effective communication is about reaching the audience. Here's the good news: the Right doesn't care about what lies on the horizon. We do, and see clearly where we're heading as a result. That means the future belongs to the Resistance.

The voices represented within these pages articulate the many forms resistance can take, leaning as much on the history of the political poster as on the particularities of current social questions, bridging general calls for direct action with granular specifics, and offering social analyses from fifty thousand feet up. It is, in short, a resistance workbook to draw inspiration from. What connects the works on these pages to every other political poster, past, present, and future, is the same thing that connects us to the audiences for them: shared spaces, and the combined power of text and image, a power that can tell us what we need most to know during times of struggle, as the work of Gran Fury did during the early years of HIV/AIDS.

Another noteworthy aspect of 1914 was the rising modernism that ushered in waves of political egalitarianism, radically changing our ideas of what political engagement might look like, and making twentieth-century social movements possible. The Information Age is that on steroids, but image literacy still lags behind technology. Perhaps it's because we misread what information technology actually is. It is a means of communication, just like broadsheets were before the turn of the twentieth century. Physical posters in physical spaces have a power that exceeds the evanescence of internet messaging. The poster comes for you where you live.

Content is what moves us to political action. Content cradles everything, from war to Katy Perry, from the Right to Rise and Resist, and there can be no political movement without ideas to propel it. Content solidifies movements, and content is what sustains them. The content it conveys is the point of the political poster, not whether it is printed on paper or shared on social media. Content is its power, and it's a power that will always belong to those who respond to its call.

Resources

Below are further resources for those in the United States looking to voice progressive causes through graphic design. There are many issue-specific resources that could not be included.

ARCHIVES AND EXHIBITION SPACES

The Amplifier Foundation is a design lab dedicated to amplifying the voices of social change movements through art and community engagement.
amplifier.org

The Ben and Beatrice Goldstein Foundation Collection at the Library of Congress is an archive of 1,688 prints and drawings from the 1880s to the 1960s that focuses on political issues and minority representation.
loc.gov/pictures/collection/bbgfc

Center for the Study of Political Graphics is an educational research archive of more than ninety thousand protest graphics spanning the nineteenth century to the present.
politicalgraphics.org

Interference Archive is an organization exploring the relationship between cultural production and social movements through an open stacks archival collection, publications, a study center, and public programs.
interferencearchive.org

The Joseph A. Labadie Collection at the University of Michigan Library is a collection of political posters, over 2,200 of which are digitized. The archive has been expanding for the past one hundred years.
quod.lib.umich.edu

Museum Impact is the first mobile social justice museum, inspiring action at the intersection of the self, society, art, and activism.
museumofimpact.org

Poster and Broadside Collection at the Tamiment Library & Robert F. Wagner Labor Archives at New York University is a broadside and poster collection with works from 1904 to 1991 focused on left-radicalism and the counterculture.
nyu.edu/library

Printed Matter, Inc. is a bookstore, archive, and distributor of artists' books with a radical bent. It also hosts politically provocative storefront window installations.
printedmatter.org

Social and Public Art Resource Center (SPARC) is an organization that reimagines and implements public art for people from all walks of life. The group's most well-known achievement is the herculean Great Wall of Los Angeles, a mural along the LA River.
sparcinla.org

ARTIST COLLECTIVES

The Artful Activist is a collective of over 230 contributors that works to unite visual artists, writers, musicians, activists, gallerists, and many others in order to create change through collaboration.
theartfulactivist.com

Artnauts is a Colorado-based collective that uses art as a tool for addressing global issues and brings together artists from all over the world. They work at the intersection of critical consciousness and contemporary artistic practice to impact change.
artnauts.org

Design Action Collective is a thirteen-member cooperative of social justice graphic designers based in Oakland, California. Their diverse members are social justice activists and organizers who offer graphic design skills and web development to progressive movements.
designaction.org

Emergence Media is a Detroit-based organization that works with artists and a wide range of collaborative partners to activate social transformation through the production of music, multimedia works, installations, tours, workshops, and special events.
emergencemedia.org

For The People Artists Collective is a group of Chicago artists of color who create artwork that uplifts and projects the struggle, resistance, liberation, and survival for marginalized communities.
forthepeoplecollective.org

Guerrilla Girls is a collective of feminist activist artists who wear gorilla masks in public to preserve their anonymity and keep the focus on the issues, as opposed to on who they might be. They use facts, humor, and outrageous visuals to expose gender and ethnic bias, and political corruption.
guerrillagirls.com

Justseeds is a worker-owned cooperative in Pittsburgh that supports political printmakers across North America to produce collective portfolios, promote effective graphic design in grassroots struggles, and work together on projects.
justseeds.org

Sol Collective is a collective in Sacramento, California that works nationally to provide artistic and cultural educational programming, to promote social justice, and to empower the youth through the arts. It hosts art exhibitions, community workshops, youth programming, and platforms for social organizing.
solcollective.org

BOOKS

Benson, Thomas W. *Posters for Peace: Visual Rhetoric and Civic Action*. University Park, PA: Penn State Press, 2015.

Bruckner, D. J. R., Seymour Chwast, and Steven Heller. *Art Against War: 400 Years of Protest Art*. New York: Abbeville Press, 1984.

Edelman, Murray. *From Art to Politics: How Artistic Creations Shape Political Conceptions*. Chicago, IL: University of Chicago Press, 2003.

Glaser, Milton, ed. *The Design of Dissent: Socially and Politically Driven Graphics*. Beverly, MA: Rockport Publishers, 2006.

Greenwald, Dara and Josh MacPhee, eds. *Signs of Change: Social Movement Cultures, 1960s to Now*. Chico, CA: AK Press, 2010.

Macphee, Josh, ed. *Celebrate People's History: The Poster Book of Resistance and Revolution*. New York: The Feminist Press at CUNY, 2010.

———. *Paper Politics: Socially Engaged Printmaking Today*. Oakland, CA: PM Press, 2009.

McQuiston, Liz. *Graphic Agitation: Social and Political Graphics Since the Sixties*. New York: Phaidon Press, 1993.

Resnick, Elizabeth, Chaz Maviyane-Davies, and Frank Baseman. *The Graphic Imperative: International Posters for Peace, Social Justice and the Environment, 1965–2005*. Boston: Massachusetts College of Art, 2005.

Scalin, Noah. *The Design Activist's Handbook: How to Change the World (Or at Least Your Part of It) with Socially Conscious Design*. Palm Coast, FL: HOW Books, 2012.

Siegel, Dmitri, and Edward Morris. *Green Patriot Posters: Graphics for a Sustainable Community*. Thames & Hudson, 2011.

Simmons, Christopher. *Just Design: Socially Conscious Design for Critical Causes*. Palm Coast, FL: HOW Books, 2011.

Shea, Andrew. *Designing For Social Change: Strategies for Community-Based Graphic Design*. Princeton Architectural Press, 2012.

Wert, Hal Elliott. *George McGovern and the Democratic Insurgents: The Best Campaign and Political Posters of the Last Fifty Years*. Lincoln, NE: University of Nebraska Press, 2015.

SUBJECT INDEX

Published by
Princeton Architectural Press
A McEvoy Group company
202 Warren Street,
Hudson, New York 12534
Visit our website at www.papress.com

Editor: Nolan Boomer
Designer: Paul Wagner

Special thanks to: Ryan Alcazar, Lucy Balcezak, Abigail Baxter, Janet Behning, Nicola Brower, Abby Bussel, Benjamin English, Jan Cigliano Hartman, Susan Hershberg, Kristen Hewitt, Lia Hunt, Valerie Kamen, Jennifer Lippert, Sara McKay, Eliana Miller, Nina Pick, Wes Seeley, Rob Shaeffer, Sara Stemen, Marisa Tesoro, and Joseph Weston of Princeton Architectural Press
—Kevin C. Lippert, publisher

Library of Congress Cataloging-in-Publication Data
Names: Lippert, Jennifer, writer of preface. | Finkelstein, Avram, 1952-
 writer of afterword.
Title: *Posters for change : tear, paste, protest.*
Description: First edition. | New York : Princeton Architectural Press, 2018.
 | Includes bibliographical references and index.
Identifiers: LCCN 2017040665 | ISBN 9781616896928 (alk. paper)
Subjects: LCSH: Social problems—Posters. | Social justice—Posters. |
 Posters—21st century.
Classification: LCC NC1849.S54 P67 2018 | DDC 741.6/74—dc23
LC record available at https://lccn.loc.gov/2017040665